Art in Context

Courbet: The Studio of the Painter

Art in Context

Edited by John Fleming and Hugh Honour

Each volume in this series discusses a famous painting or sculpture as both image and idea in its context – whether stylistic, technical, literary, psychological, religious, social or political. In what circumstances was it conceived and created? What did the artist hope to achieve? What means did he employ, subconscious or conscious? Did he succeed? Or how far did he succeed? His preparatory drawings and sketches often allow us some insight into the creative process and other artists' renderings of the same or similar themes help us to understand his problems and ambitions. Technique and his handling of the medium are fascinating to watch close up. And the work's impact on contemporaries and its later influence on other artists can illuminate its meaning for us today.

By focusing on these outstanding paintings and sculptures our understanding of the artist and the world in which he lived is sharpened. But since all great works of art are unique and every one presents individual problems of understanding and appreciation, the authors of these volumes emphasize whichever aspects seem most relevant. And many great masterpieces, too often and too easily accepted and dismissed because they have become familiar, are shown to contain further and deeper layers of meaning for us.

Art in Context

Gustave Courbet *was born at Ornans near Besançon on 10 June 1819 and died on 31 December 1877 at Le Tour de Peilz near Vevey in Switzerland. His father was a farmer. In 1837 he was enrolled as a boarder at the Collège Royal, Besançon, but hated it, his only passion being painting. He left for Paris in 1840 and from then onwards divided his time between Paris and Ornans. He exhibited at the Salon from 1844 onwards but generally his submissions were rejected. At the Salon of 1850–51 his works created a scandal. This date marked the birth of Realism of which he was the leading spirit. His reputation was not established until about 1860. In 1871 he joined the Commune, and on its suppression he was pronounced responsible for the destruction of the Vendôme column and imprisoned. He passed his last years in exile in Switzerland.*

The Studio of the Painter *is painted in oil on canvas (359 x 598 cm.). The full title is* Intérieur de mon atelier, allégorie réelle déterminant une phase de sept années de ma vie artistique. *It was painted in 1854–5 at Ornans and exhibited in Paris in 1855 in Courbet's famous one-man show entitled 'Realism. G. Courbet'. It was exhibited twice more during Courbet's lifetime, at Bordeaux and Vienna, but was still in his possession when he died. In 1920 it was acquired by the Louvre.*

The Viking Press New York

Courbet: The Studio of the Painter

Benedict Nicolson

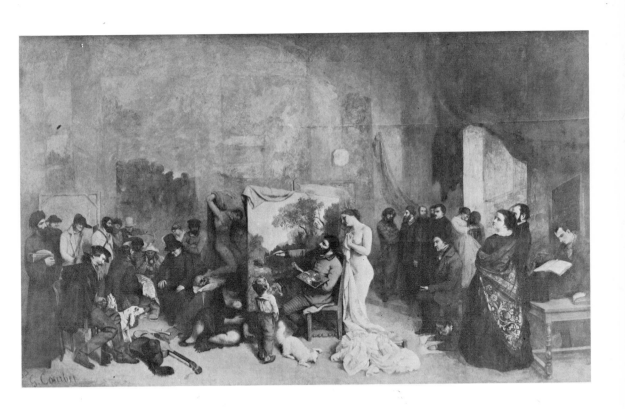

Copyright © 1973 by Benedict Nicolson
All rights reserved
Published in 1973 by The Viking Press, Inc.
625 Madison Avenue, New York, N.Y. 10022
SBN *670-24425-2*
Library of Congress catalog card number: 72-78199
Filmset in Monophoto Ehrhardt by Oliver Burridge Filmsetting Ltd, Crawley, England
Color plate reproduced and printed by Colour Reproductions Ltd, Billericay, England
Printed and bound by W. & J. Mackay Ltd, Chatham, England
Designed by Gerald Cinamon

For Simon

Reference colour plate at end of book

Historical Table

1847

1848 February: Overthrow of July Monarchy;
 Proclamation of Second Republic
 June: Defeat of the radicals
 December: Louis Napoleon President

1849

1850

1851 December: *Coup d'état* of Louis Napoleon

1852 December: Louis Napoleon Emperor

1853

1854–6 Crimean War

1856

1857 Indian Mutiny

1859 Outbreak of War of Italian Liberation

1861 Outbreak of American Civil War

1862

1863

Couture, *Romans of the Decadence*		1847
	Michelet, *Histoire de la Révolution*	1847–53
	Chateaubriand, *Les Mémoires d'Outre-Tombe*	1848
Delacroix commissioned to decorate S. Sulpice (completed 1861)		1849
Courbet, *A Burial at Ornans*	Death of Balzac	1850
Death of Turner		
Ford Madox Brown, *Work* (begun)		
	Victor Hugo, *Les Châtiments*	1853
1854–5 Courbet: *The Studio of the Painter*		
Ingres, *La Source*		
	Baudelaire, *Les Fleurs du Mal*	1857
	Flaubert, *Madame Bovary*	
1858–9 Millet, *The Angelus*		
1858–62 Degas, *Portrait of the Bellelli Family*		
	Victor Hugo, *Les Misérables*	1862
Manet, *Le Déjeuner sur l'herbe*	Renan, *Vie de Jésus*	1863

Courbet : The Studio of the Painter

It has always seemed to me that the only sensible way of examining a picture – especially a key picture in the history of art like Courbet's *Studio of the Painter* [colour plate at end of book] – is to begin by deciding on what is there, before going on to consider what it is doing there. This sounds self-evident. But it is surprising how many people never look properly, and therefore never reach their jumping off ground of understanding; more often they rush too quickly to explanations, and get things wrong because they have skimped the preliminary stages. I propose to begin by making an inventory of the contents and inmates of Courbet's studio before attempting to explain what it is all about. In this way I pay the penalty of being earthbound for the time being. But it is best to be sure of one's ground before risking the air.

I shall start by recording what facts Courbet himself supplied about his picture, and then fill in the gaps. Luckily for us he wrote a long description of the décor and the cast on this claustrophobic stage when it was less than half finished, in a letter to his friend and fellow-realist Champfleury, from his native town of Ornans in the Franche-Comté at about the end of January 1855. It has to be admitted that when he wrote it he had only been intermittently at work on the picture a month or so, and still had six weeks or so before it had to be finished in time for its exhibition.[1] Subsequently he made changes, adding a few more figures and eliminating others. But it was sufficiently advanced by that time, in his mind at any rate if not yet on canvas, for the description to serve as a guide to what we see. For the moment I am leaving out those parts of the letter, and of letters to other friends written during work in progress, which help to explain what the author intended by his picture, but of course it

is not always possible or desirable entirely to separate facts from ideas. They tend to get mixed up.

'In spite of being on the verge of hypochondria I have undertaken an immense painting, twenty feet long by twelve high;[2] perhaps larger than the *Burial* [*A Burial at Ornans* [1], another immense

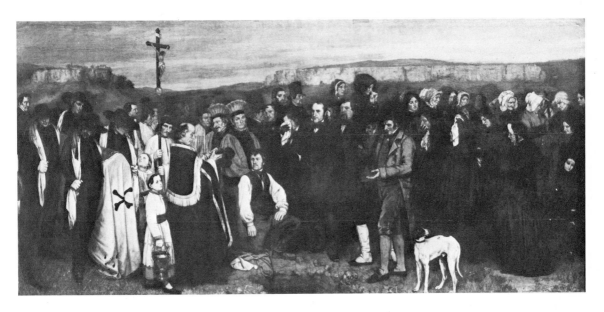

1. *A Burial at Ornans*, 1849. Courbet

canvas he had embarked on at Ornans five years earlier] which will prove to you that I am not yet dead, or realism either, for this is realism . . . In it are the people who thrive on life and those who thrive on death; it is society at its best, its worst, and its average . . .

'The scene is laid in my studio in Paris. The picture is divided into two parts. I am in the centre, painting [3P in the key]; on the right are the "shareholders", that is my friends, the workers, the art collectors. On the left the others, the world of trivialities: the common people, the destitute, the poor, the wealthy, the exploited, the exploiters; those who thrive on death. On the wall in the background hang the *Return from the Fair* and *The Bathers* [two of his own recent paintings] and [on the easel in the foreground] the picture I am working at . . .

'I will enumerate the figures beginning at the extreme left. At the edge of the canvas is a Jew [2A] I saw in England as he was making his way through the swarming traffic of the London streets, reverently carrying a casket on his right arm and covering it with his left hand; he seemed to be saying: "It is I who am on the right track"; he had an ivory complexion, a long beard, a turban, and a long black gown that trailed to the ground. Behind him is a self-satisfied curé [2B] with a red face. In front of them is a poor weather-beaten old man, a republican veteran of '93 [2C] ninety years of age, holding a begging bag in his hand and dressed in old white linen . . . He is

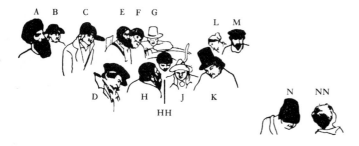

2. Key to the personages on the left of *The Studio*:

A. The Jew
B. The curé
C. The veteran of 1793
D. The huntsman
E. The huntsman Maréchal
F. The farm labourer
G. The reaper
H. The textile pedlar
HH. The strong man
J. The clown
K. The undertaker's mute
L. The labourer's wife
M. The labourer
N. The Irishwoman and child
NN. The Franc-Comtois peasant boy

looking at a heap of "romantic" cast-offs at his feet (he is pitied by the Jew). Next come a huntsman [2E], a reaper [2G], a professional strong man [2HH], a clown [2J], a pedlar of cheap textiles [2H], a labourer's wife [2L], a labourer [2M], an undertaker's mute [2K], a skull on a newspaper, an Irishwoman suckling a child [2N], a lay figure. The Irishwoman is also a memory of England; I saw this woman in the streets of London; her only garments were a black straw hat, a torn green dress, a frayed black shawl under which her arm held a naked baby. The textile pedlar presides over the whole group; he displays his rubbish to everybody, and all show the greatest interest, each in his own way. Behind him [that is, at his back] a guitar and a plumed hat occupy the foreground.

'Second part: then come the canvas on my easel and myself painting, showing the Assyrian profile of my head. Behind my chair stands a nude female model [3Q]; she is leaning against the back of my chair as she watches me paint for a moment; her clothes are on the

floor in the foreground; there is a white cat near my chair. Beyond this woman is Promayet [3R] with his violin under his arm, as he is posed in the portrait he sent me; next to him are Bruyas [3S], Cuenot [3U], Buchon [3V], Proudhon [3T] (I would like to see the philosopher Proudhon, who looks at things as we do; if he would sit for me I should be pleased; if you see him, ask him if I may count on him). Then comes your turn [3W] in the foreground; you are sitting on a stool with your legs crossed and a hat on your knees. Beside you, still nearer the front, is a woman of fashion, elegantly dressed, with her husband [3Y]. Then at the far right, sitting on a

3. Key to the personages on the right of *The Studio*:

P. Gustave Courbet
Q. The model
R. Alphonse Promayet
S. Alfred Bruyas
T. Pierre-Joseph Proudhon
U. Urbain Cuenot
V. Max Buchon
W. Champfleury
X. Pair of lovers
Y. Art collectors
Z. Jeanne Duval
ZZ. Charles Baudelaire

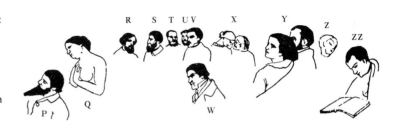

table with a single leg [showing], is Baudelaire [3ZZ] reading a large book; next to him is a negress [3Z] looking at herself very coquettishly in a mirror. At the back in the window embrasure can be seen a pair of lovers [3X] whispering to each other of love; one is seated on a hammock; above the window are voluminous draperies of green cloth; against the wall are some plaster casts, a bracket holding the statue of a little girl, a lamp, and a few pots; also the backs of canvases, a screen, and nothing more except a great bare wall . . .'[3] Thus Courbet described his new picture to his old friend.

Other letters add practically nothing to this. About the end of November or beginning of December of the previous year he had described to his friend Bruyas in Montpellier how he had done a sketch for the picture and had transferred it to the canvas; how there were to be thirty life-size figures (although he later added two or three, and cut one out, there are in fact precisely thirty if one omits

the lay figure); how he proposed to show on his easel in the centre a landscape with a miller and donkeys carrying sacks to a mill; how he had two and a half months in which to finish it before it was to go on exhibition, which gave him (allowing for interruptions) two days per figure. In a letter of March 1855 to Bruyas, by which time he had almost finished the picture, he tells him he (Bruyas) occupies a magnificent place [3s], and is in the pose of *The Meeting* [43] 'only the conception is different'; *The Meeting* being a picture of himself being welcomed by Bruyas near Montpellier which Courbet had painted the previous summer on a visit to his friend. Having given up hope of getting Proudhon to sit for him, he writes to Champfleury again, about the same time as to Bruyas: 'I want you very much to let me have some portrait or other of Proudhon, some lithograph, so long as it resembles him. I have no other means of doing his portrait, given that I shall be finishing my picture at Ornans. Please send it me as soon as possible.'[4]

Let me first clear out of the way all the objects that do not appear in the picture, before considering the ones that do. Courbet had at

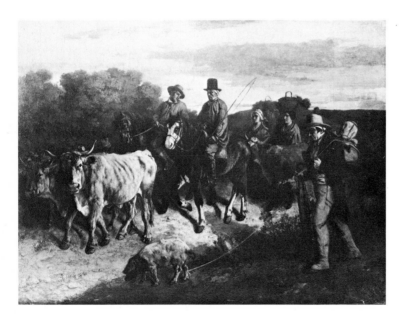

4. *The Peasants of Flagey returning from the Fair*, 1850. Courbet

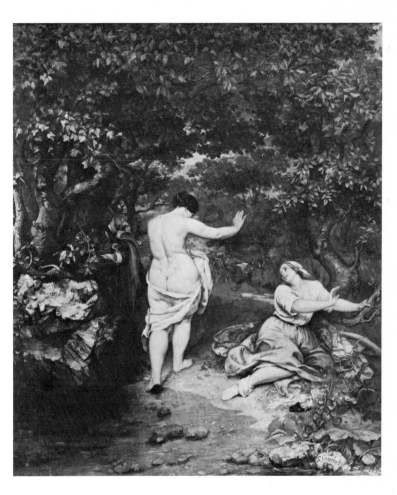

5. *The Bathers*, 1853.
Courbet

first thought of introducing more objects into the setting of his
studio than are now clearly seen. He proposed to show hanging on
the wall his two large pictures, the *Peasants of Flagey returning from
the Fair* (now in the Besançon Museum [4], or another version) and
The Bathers [5]. It was characteristic of him to select as a gesture of
defiance two works which had been violently attacked at the Salons
of 1850–51 and 1853 respectively. 'This is realism', he writes of
The Studio to Champfleury, and these two had been realist
manifestos, life in the raw set in his own countryside of the Doubs,
an affront to sophisticated Paris. There is the ghost of a large

picture above the pedlar and his dupes where one can still discern a landscape which began life as the *Return from the Fair*,[5] but it is now almost inscrutable; there is no sign at all of *The Bathers*. And the bracket with the statue of the little girl, the lamp and pots, are also missing (although the lamp must have been visible originally since it appears in the caricature [6]). All that remains – the plaster

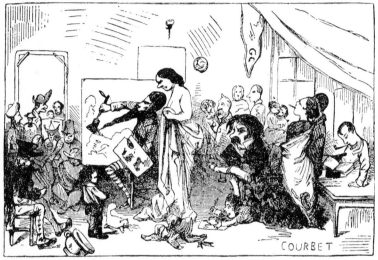

M. Courbet dans toute la gloire de sa propre individualité, allégorie réelle déterminant une phase de sa vie artistique. (Voir le programme, où il prouve victorieusement qu'il n'a jamais eu de maître... de perspective.

6 *(left)*. Caricature of *The Studio*, 1855. Quillenbois

7. Detail of *The Studio*: the huntsman

medallion, a canvas turned to the wall, the screen (which is now difficult to differentiate from the window embrasure), the curtains, and a few other strips which were once intended as pictures hanging on or propped against the wall[6] – now serve no further purpose than to evoke the atmosphere of a typical Paris studio of the middle of the century. Evidently as the weeks passed Courbet came to realize that only by leaving the background indeterminate could he achieve his aim, of concentrating the attention on the main actors. Nevertheless, the background is unsatisfactory in the state he left it. There are many parts of the picture, not only in these areas, which could have done with more work and care. Although in some figures, notably in the central group, the art collectors, and the splendid huntsman [7], rich pigment is applied with the palette

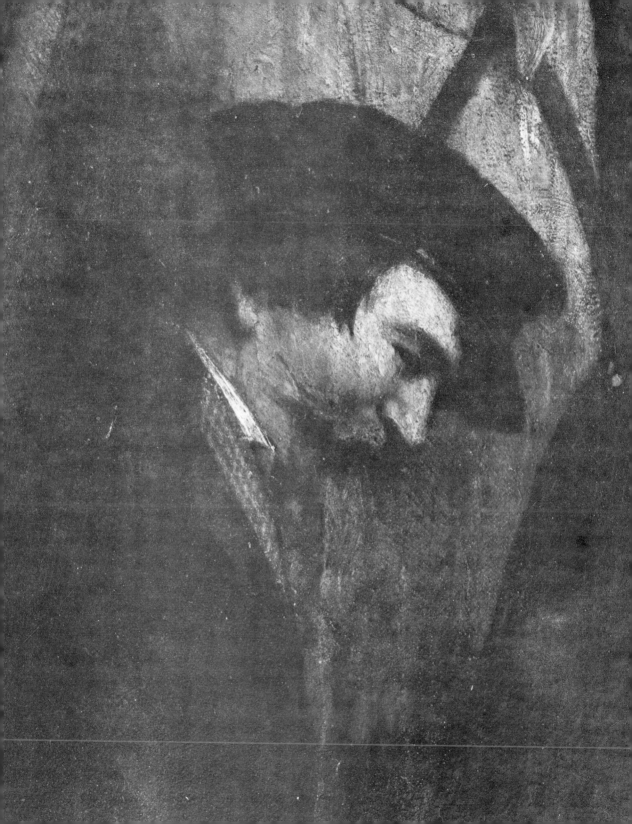

knife, there are other groups, as well as in the background, which are thinly painted and lack substance, with the result that in many places the reddish-brown preparation shows through. Courbet was hard pressed for time, and would surely have tidied up the mess, made the forms more explicit and substantial, had he been able to devote a few more weeks to the picture's perfection. It had to be in Paris by a given date, and we know he was working frantically up to the last minute to have it ready for dispatch.

He tells Bruyas that he thought of showing on his easel a landscape with a miller and donkeys carrying sacks to a mill; but his substitute landscape of the valley of the Loue [8], which perhaps existed but has never been identified, is deserted. He was contemplating a variant on an actual picture he had just executed (1854) at Ornans, dedicated to a friend named Martin, a miller, entitled *The Miller, his son and the donkey*. The miller on his donkey listens to the remarks of two men and a woman who carries a child on her back.[7] In the end he decided that all that was required was the Loue, transported to the dead centre of the Paris studio, and given pride of place there, to confound the smart critics with his defiant provincialism.

There is no sign of the hammock on which one of the lovers was supposed to be seated, and the negress has been eliminated. She survives as a *graffito* on the wall beside Baudelaire's head [34], preening herself in front of the tall mirror which is hinged to two arms which rise almost to its summit. She is only visible as a result of the thinning of the paint surface in this area, which was intended to cover her up. Courbet does not confess it to Champfleury, but this is Baudelaire's mistress, Jeanne Duval, rendered in a silhouette strikingly reminiscent of Baudelaire's own drawings of her of about 1854 to which Courbet plainly had access but did not imitate exactly. Although he found it painful to desert her altogether, Baudelaire's relations with her were then deteriorating: he had taken up with the actress Marie Brunaud in 1854–5, and shortly afterwards became deeply involved with Madame Sabatier. One

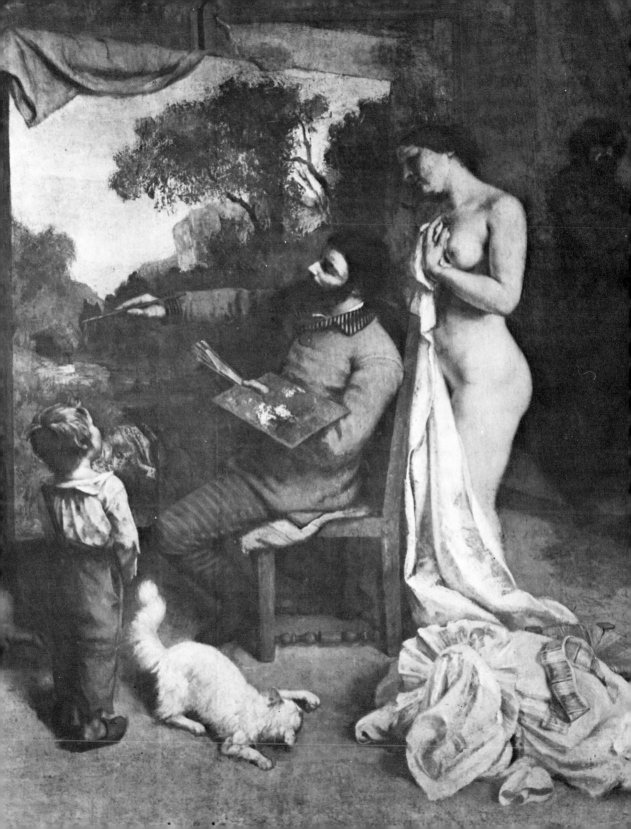

imagines that it was on his own insistence that the features of the rejected lover beside him were blotted out before the picture was allowed to go on view in Paris in the summer of 1855[8], but this was a request one would expect to be transmitted by word of mouth.

Then there are the figures not described to Champfleury or to Bruyas, which one supposes were added subsequently. He keeps silent on the not easily identifiable figure [2F, 22], leaning for support on the background huntsman, with the reaper on the other side. Silvestre is probably right in regarding him as a farm labourer. The second huntsman [2D, 7] holding his two dogs on a leash and clasping his gun, is displayed too prominently in the left foreground to have been omitted from the description by mistake. One imagines that only at a later stage he realized that some striking and prominent figure, who as a local character would have been at hand for a sitting, unlike most of the figures to the right of the easel, was needed to balance Champfleury and the art collectors on the other side. Similarly he would hardly have gone out of his way to record the angora cat, and not the little boy beside it [2NN], admiring the canvas on the easel, if the latter had already been in his mind. There is another boy sketching on the floor at Champfleury's feet who must also have been an afterthought, no doubt suggested to him as a contrast of naïve truth to the outworn lumber of romanticism in the shape of guitar, dagger and slouch hat on the corresponding side of death.

Let us see what more the picture will yield that Courbet himself does not supply. Although it was painted entirely in his native town of Ornans and only sent to Paris for exhibition on its completion, Courbet insists that it is his Paris, not his Ornans, studio, that is depicted. This was the studio he had taken on the first floor of 32 rue Hautefeuille at the corner of the rue de l'Ecole de Médecine, where he was to remain until 1871. The house was demolished about seven years after he left it, to be replaced by the dull stones of the Medical Faculty. What a disappointment, to those who revel in

9. Courbet's studio, *c.* 1870.
A.-P. Martial

historical melancholy, the rue Hautefeuille, to the south of the Place St Michel, now is! The imagination has to work wonders in order to reconstruct the house where Baudelaire was born a few yards northwards, now also demolished; and the famous Brasserie Andler, within a stone's throw of Courbet's studio, the factory of Realism, where Courbet used to sit arguing and drinking into the small hours with artists and writers, presiding over the burial of romanticism and of picturesque Bohemia. No eye-witness accounts, however vivid, can compensate for their loss. His house [9] was a converted Priory, and the room we see in the picture was the apse of the chapel, with the roof for a ceiling. There was a window looking out on to the rue de l'Ecole de Médecine, as well as a large skylight. A wooden partition in the corner enclosed a tiny bedroom. According to a near-contemporary description, there was very little furniture: a divan, half-a-dozen chairs, an old dresser with a curved front, a small table littered with pipes, beer glasses and newspapers. There were pictures of all shapes and sizes, some without frames and hung on the wall, others stacked with their backs to the wall. 'In the corners were huge rolls of canvas resembling carefully reefed sails. No luxury whatever, not even ordinary comfort.'[9] The elegant art collectors had to put up with the dust. There was to be no parade for their benefit. They could take it or leave it, and usually left it. The painter's studio was the equivalent of the carpenter's tool shed: a place to work in, drawing its beauty, as Castagnary put it, from its size and the quality of its light, rather than from exotic plants craftily distributed.

Courbet shows his studio even barer than it was in fact. It cannot be said to be exactly cluttered up, as we know it to have been. There is a lay figure which could be made to serve as a model for a *St Sebastian* or a *St Bartholomew* significantly placed to the left of the easel among those who 'thrive on death', balancing the nude model to the right, so as to bring out the contrast between artifice and shining truth. The lay figure is the symbol of the academic art he

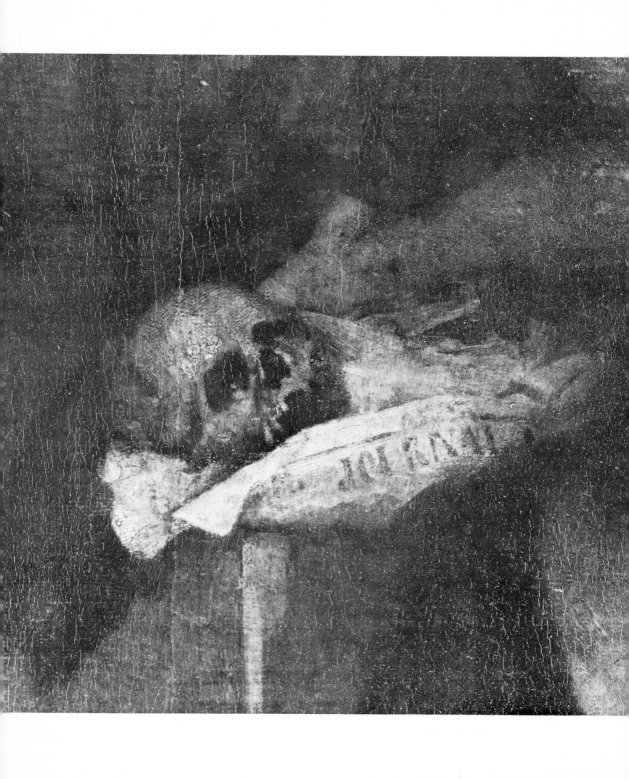

had rejected, just as the skull at the saint's feet [10], resting on a copy of the *Journal des Débats*, is the symbol of the death of the Paris press which exalts academic art and ridicules the directness of Courbet's vision. On the wall to the left of Promayet [3R] hangs a plaster medallion, the work of Courbet himself, who was already experimenting in bas-relief sculpture before the mid 1840s. And that, along with the vague hangings and curtains, about completes the props.

The painter is seated in front of his easel [8], adding a stroke to his landscape. This is not the way an artist normally confronts a canvas – in fact the surviving photographs of Courbet himself in the act of painting show him seated square to his canvas. A more plausible pose is that of the self-effacing Vermeer who in the Liechtenstein picture sits with his back to us, more concerned that we should see his picture than his face. Hogarth, on the other hand, in the self-portrait in the National Portrait Gallery, London, manages to show us both. And Courbet, whose modesty about his appearance and image was never his outstanding quality, is also determined that we should inspect both the picture and the 'Assyrian' profile. He was well capable of originating this phrase. 'Assyrian' had come to mean something quite specific by that time. In 1843 Paul-Emile Botta, after months in Northern Mesopotamia, had come on a mound at Khorsabad and uncovered a small part of the fortress–city–palace of Sargon II. Publication began in 1849–50 of large fully-illustrated volumes of *Monument de Ninive* – but it was not that Great City at all; this was discovered by Layard in 1846 several miles away. Much of the sculpture was brought back to Paris where it attracted widespread attention.[10] The association of Khorsabad with Courbet's profile was soon taken up by Théophile Silvestre, who in 1856 commented on his 'remarkable face' which 'seems to have been singled out for adaptation to an Assyrian bas-relief'. Inevitably the caricaturists, even before the publication of the relevant volume of Silvestre's book, got to work on the famous profile. *L'Illustration* of 21 July 1855 carried caricatures of *The*

10. Detail of *The Studio*: skull on newspaper

Meeting and *The Studio* [6] when they were first exhibited in Paris, showing Courbet with a long corkscrew beard. This survived in the majority of the caricatures until Nadar imagined the painter (in

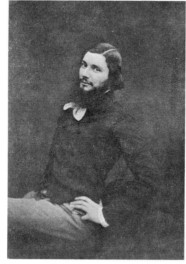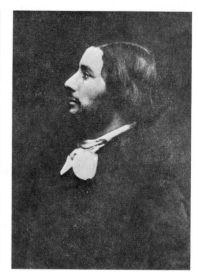

11 *(left)*. *Self-Portrait*, 1852. Courbet

12 *(middle)*. Photograph of Courbet, *c.* 1852. Lalane and Defonds

13 *(right)*. Photograph of Courbet, *c.* 1855. Nadar

1858) as an actual figure on an Assyrian relief. The convention lingered on into the mid 1860s, long after his beard had become bushier again, and his features and body had begun to swell.[11] Throughout the history of caricature, a clever idea rapidly becomes a cliché, and ends by being a falsehood.

The self-portraits and photographs bear out the evidence of the caricatures. The confident young face that smiles out at us in 1852 from the British Museum drawing [11] shows him wearing a square-cut beard. By the summer of 1854 when he had reached the age of

35 he had acquired the longer, more pointed beard we are presented with in the *Self-Portrait in the Striped Collar* [15], *The Meeting* [14], and *The Sea Shore at Palavas*. He was pleased with this, since it

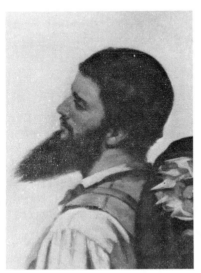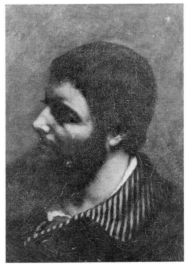

14 *(left)*. Detail of *The Meeting*, 1854. Courbet

15 *(middle)*. *Self-Portrait in the Striped Collar*, 1854. Courbet

16 *(right)*. *Self-Portrait*, 1855. Courbet

survived various illnesses into the following winter, reappearing as the raven-black beard of *The Studio* [17]. The photographs are not so precisely datable but they can be shown to tell the same story. The one by Lalane and Defonds [12] with a rather square beard, slim waist and youthful face, must show him about the time of the British Museum drawing. The photographs by Nadar [13], Durand et Cie and Pierson (*c*.1855) and Radoux (1858) show that he has allowed the beard to grow, and though he can hardly yet be called fat, he is moving in that direction.[12]

Many writers have remarked on his beauty as a young man, on his eyes 'as large and gentle as those of an ox'. This is confirmed by all portraits of him by others as well as by himself. He had the robustness characteristic of the Franc-Comtois, who were a near-mountain race. He also had a tendency to obesity which got the better of him in later years when misfortune fell upon him. He complained to Max Buchon in September 1854 that he had become 'disgustingly fat' while staying at Montpellier, but that an attack of cholera had thinned him down. Six weeks later he reports to Bruyas, after an attack of jaundice, that he has lost his *embonpoint*, but he does not look in *The Studio* as though he were in any danger of wasting away.[13] But then the very decision to embark on such an ambitious project helped him to regain his strength.

Courbet did not trouble to paint a new self-portrait for *The Studio*, but based his features [17] on a head-and-shoulders he had painted for Bruyas the previous summer at Montpellier, known as *Self-Portrait in the Striped Collar* [15]. He had borrowed the dark green jacket with the dark grey stripes from Bruyas, who is seen wearing it in his own portrait in *The Meeting* [43]. They both wear it in *The Studio* [17, 44]. The only change in the two heads [15, 17] is the tilt. In the late autumn of 1854 when he was just beginning on *The Studio*, Courbet wrote to Bruyas asking him to send the head-and-shoulders to Ornans, adding that he proposed to keep it as short a time as possible, and to return it. This he evidently did, because in March of the following year he wrote to Bruyas to say he intended to include it in the International Exhibition that spring, and asked him to send it direct to Paris with its frame for this purpose.[14] During the brief period when he had it, he traced it on to paper, transferring his tracing to the new canvas, slightly tilting it in the process. That this copy [16] is after Bruyas's picture and not after the lost sketch[15] for *The Studio* is proved by the fact that it fits the dimensions and format of the *Self-Portrait in the Striped Collar* exactly.[16] There must have been similar tracings of other heads for *The Studio* from portraits he had borrowed, which have

17. Detail of *The Studio*: Gustave Courbet

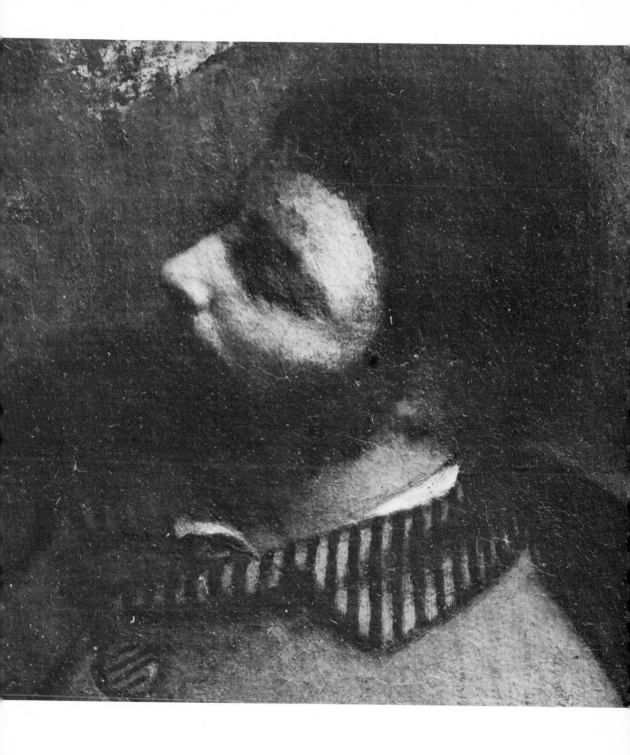

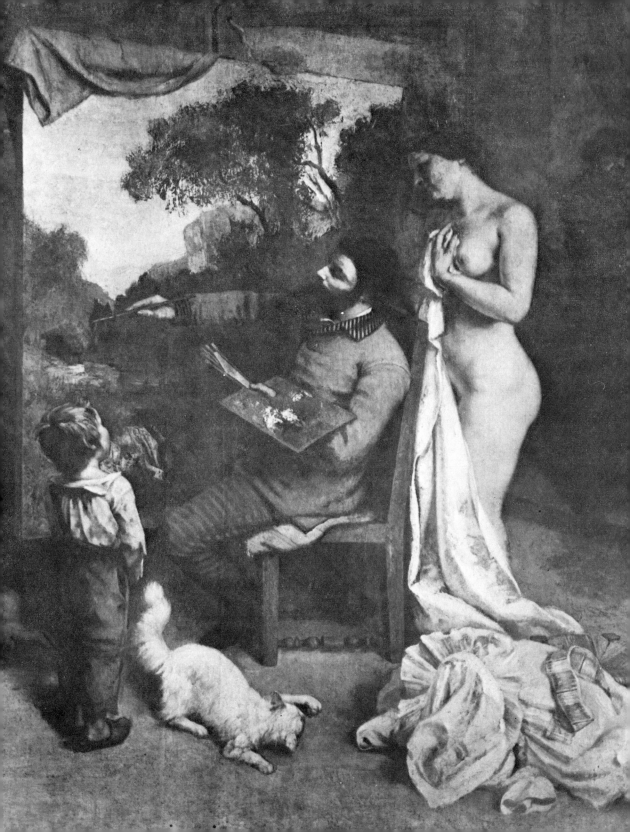

18 (*left*). Detail of *The Studio*

19. Photograph, *c.* 1854.
J. V. de Villeneuve

not come to light. Some must have got swept up with the studio dust.

The little Franc-Comtois peasant beside him [18], sockless and in sabots, remains uncorrupted by knowledge of what Art is about. But he recognizes art with a small 'a' without difficulty, because he stands entranced as his own valley of the Loue comes alive before his eyes. The model behind the chair [18] has cast off her pale pink dress and waits patiently to take up any pose that is required of her, as a naked bather, not as a nude nymph. Silvestre tells us that she personifies Truth, and we have to take his word for it, because he was close to Courbet and an accurate reporter. This means that in spirit she is guiding his brush, preventing him from putting in any stroke that does not accord with Nature, acting the role of Mrs Garrick who inspires her husband in the Hogarth double portrait in the Royal Collection, or of Colley Cibber's daughter guiding her father's pen in a Van Loo engraving.[17] In the letter I have quoted many times, written when Courbet was embarking on his picture, he asks Bruyas to send him 'that photograph of a naked woman I told you about. She is to take her place behind my chair, in the middle of the picture.' The photograph has not been traced, but one very like it [19], of the same model by the same photographer done at the same time (*c.* 1854), has survived.[18] Perhaps one day some student will be lucky enough to hit on the precise prototype.

The left-hand group [20] need not detain us too long, because little is to be extracted from it at this stage that Courbet himself does not report to Champfleury. Let us start as he did from the extreme left with the Jew he saw in London [2A]. It is perplexing that he should say that both this miserly, sanctimonious creature, and the destitute Irishwoman suckling her child at the foot of the easel [2N], were glimpsed in the London streets, because nothing is otherwise unequivocally known of any visit to England. And yet it must have taken place, for there would be no point in making it up. Silvestre, who ought to know, tells us that 'he would recall, in order to give his story more local colour, the conversation he had in

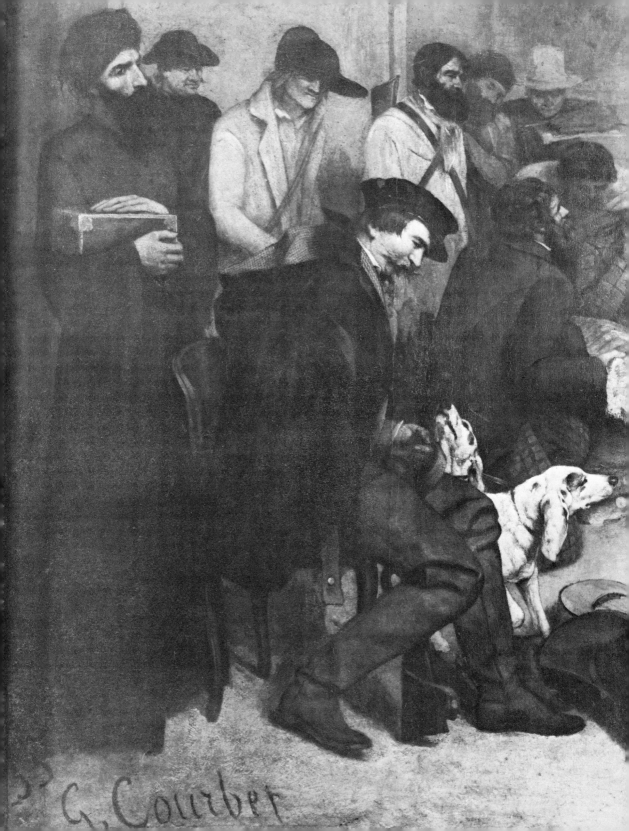

G, Courbet

20. Detail of *The Studio*

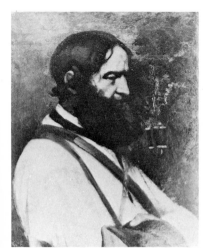

21 *(below left)*. *Huntsman Maréchal*, *c*. 1853. Courbet

22 *(below right)*. Detail of *The Studio*: Maréchal, the farm labourer and the reaper

England after the February revolution, with Hogarth the painter of manners, who died in 1764'.[19] Though the talk with Hogarth is a typical Courbetism, there is no reason to suppose that the first half of the sentence was untrue, and that he was not in London in 1848. He does not have to document his every journey (and he was always making them) for the historian's benefit. Even the remark about Hogarth is not totally nonsensical. If he had talked with Gainsborough, then indeed we would have thrown up our arms in despair. But Hogarth was a rebel after Courbet's own heart, who also clung passionately to his own local traditions, drawing the breath of life from them; who was perpetually at loggerheads with patrons and fellow artists; who mistrusted the codification of art; who stopped at nothing to replace glamour by humdrum life.

Next come the curé [2B] with his well-lined pockets; the republican veteran [2C] in his German hat who is on the 'wrong' side of the easel because he has fallen on hard times, in spite of having once gloriously voted the death of a king (his begging bag is now hidden behind the huntsman's sack); and the huntsman [22, 2E], based on a portrait Courbet had painted in about 1853 of a certain Maréchal [21], a blacksmith at Amancey (Doubs), puffing at his

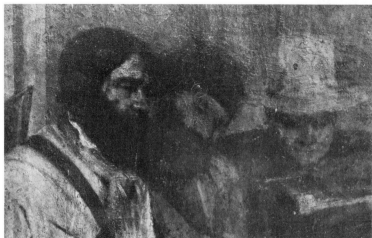

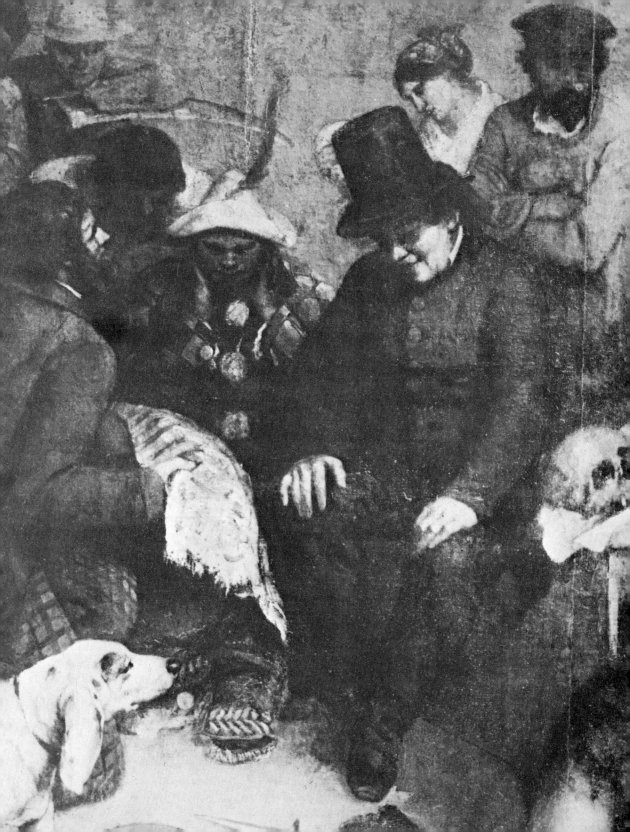

rustic pipe. Leaning on him is the supposed farm labourer [2F] not mentioned in Courbet's description to Champfleury, with the reaper [2G] on his left, resting on his scythe. Then comes the group [23] with the textile pedlar [2H] exploiting three ignorant and starry-eyed spectators: the fairground strong man [2HH], nearly in the pose of one of the figures in Courbet's *Wrestlers*, and to his left the clown [2J] – both picturesque figures, drawing their pitiful wages from the itinerant fairs; and to their left, wearing a top hat and with his hands like M. Bertin's resting on his knees, the harmless dupe, the *croque-mort*, the undertaker's mute [2K]. It used to be thought that this represented Courbet's grandfather on his mother's side, the wine-grower Oudot, whose republicanism and anti-clericalism profoundly affected Courbet as a youth. He appears on the extreme left of *A Burial at Ornans* behind the pall-bearers [24]. It is not at all the same face. The top-hatted pocket Bertin is surely younger, and Oudot would in any case never be playing the

23 *(left)*. Detail of *The Studio*

24. Detail of *A Burial at Ornans*

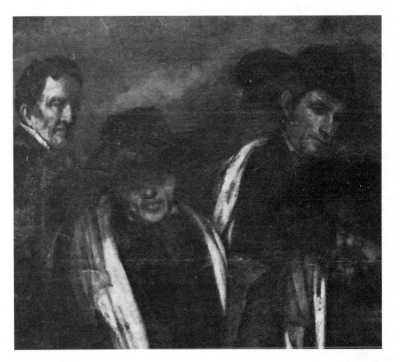

role of a dupe, having remained, in Castagnary's words, 'until the end faithful to the Revolution'. Buchon wrote that 'all Courbet's works in a major key stem from his grandfather'. Moreover, he is believed to have died in 1848 over the age of 80 and only to have been introduced posthumously into the *Burial*, adapted by Courbet from an earlier portrait of him.[20]

We are left with that spectacle of abject poverty in the form of the Irishwoman [2N], like Baudelaire in his corner ignored by everybody; and the labourer and his wife [2M, L]: he with his arms folded, indicating that he is out of work; she recalling, like the strong man, one of Courbet's earlier pictures, this time *The Sleeping Spinner* [49] in the Bruyas collection. This accounts for seventeen, to the left of Promayet [3R], out of the twenty-nine human and sub-human visitors to the rue Hautefeuille. There are also two groups of still life: the skull on the newspaper symbolizing the death of journalism, and the guitar, dagger, buckled shoe and plumed hat at the huntsman's feet symbolizing the death of romanticism – by which Courbet himself had once been seduced, but which he now resolved to replace by real life. The artist at first intended the veteran of 1793 to gaze wistfully in their direction, at his own romantic past, but now the stolid huntsman has intervened to hide them from his view.[21]

Let me first dispose of the anonymous or semi-anonymous figures to the right of the easel, before turning to the easily recognizable characters. Naturally the lovers [25] did not need to be individualized: they take up their place by the window as symbols of light and freedom. Like Courbet himself they are not checked by the handcuffs of marriage, and have nothing but their irresponsible happiness to bother about. The child at Champfleury's feet is the symbol of free art, just as the lay figure is the symbol of art enslaved. He is engaged on outlining a crude sketch of a full-length figure on a sheet of paper stretched on the studio floor. Like the little peasant boy admiring the canvas, he has had no training in art schools, and so the future of art lies with him.

25. Detail of *The Studio*: the lovers

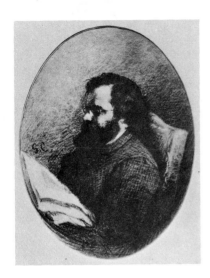

26 *(left)*. Detail of *The Studio*: the art collectors

27 *(above)*. *François Sabatier*, *c*. 1854. Courbet

More enigmatic are the art collector and his wife [26], occupying prominent positions in the right foreground. They have come on a visit to the studio with the intention of buying something. If it were foreseen that they would go away empty-handed, Courbet would have been quick to move them over to the other side, because here iconography has the whip hand over design. They are rich, and dressed in their finery. He is half hidden like the corresponding bourgeois in Seurat's *La Grande Jatte* behind his glamorous wife in crinoline and shawl. It has been ingeniously suggested that they represent M. and Mme François Sabatier, neighbours of Bruyas near Montpellier with whom Courbet was in touch in the summer of 1854. And though we do not see much of the art collector's face, there is a faint resemblance with the black chalk profile of Sabatier done by Courbet at about this time [27]. We do not know exactly when Courbet stayed with Sabatier at La Tour de Farges, near Montpellier, but it was either during the summer of 1854 or when he was back there three years later. Nor do we know the precise date of his deliciously straightforward, Corot-like landscape, *The Bridge at Ambrussum* (Musée Fabre, Montpellier), which Courbet painted for him when he was his guest. Sabatier was the kind of man to appeal to Courbet: a rich socialist with a love of modern art, like Buchon both a Fourierist and translator of German literature, and therefore a potential patron and sympathetic friend. He wrote criticism under the name of Sabatier-Ungher, and praised Courbet's *Burial* in his Salon of 1851 in a very up-to-date, anti-romantic phrase: 'Here we have democracy in art.' He married a famous contralto, Caroline Ungher. The clue to their identification in *The Studio* should reside in the lady, but the iconography of Madame Sabatier (not the same as Baudelaire's) is far from clear, and the cut of Sabatier's beard, for instance, is quite different.[22] I have still to be persuaded that we are dealing with the same couple.

Nowhere in French art before Fantin-Latour's *Batignolles Studio*, which owes a great deal to Courbet's picture, can one discover such a galaxy of contemporary talent grouped together on

a single canvas, as here behind Courbet's back. I shall not deal with them in the order they are shown here, but in the approximate order of the duration of their acquaintance with the artist, so that the account of them will also incidentally provide an outline of Courbet's own intellectual and moral development up to that moment, and fix the stage in it he had reached.

Throughout that winter of 1854–5 Courbet, except for occasional journeys, was immured in a remote little town in the Franche-Comté. It was not like being in Paris where he might summon his friends to sit for him. If he wished to introduce their portraits into his current picture, he had to fall back on prefabricated likenesses. The clearly identifiable portraits to the right of the easel, with the possible exception of Cuenot, like those of Maréchal, the painter himself, the model and the obliterated Jeanne Duval, are based on existing portraits which Courbet succeeded by one means or another in gathering into his Ornans studio. Let me begin with the musician Alphonse Promayet [28], since Courbet had known him ever since he could remember. In the letter to Champfleury he says Promayet is posed as 'in the portrait he sent me'. This is the three-quarter length of 1851 which belonged to Promayet, which Zacharie Astruc saw in Courbet's studio in Paris in 1859, and which has come to rest in the Metropolitan Museum, New York [29]. Courbet has taken it over more or less without change, even to the slope of the violin. In a letter of 1873 to his sister, Mme Reverdy, he claimed it as perhaps the best portrait he had done[23] – but this, as so often with his loaded statements (he was trying to sell the picture at the time, which he had either kept, or had reverted to him after Promayet's death) must be taken with a grain of salt. We can recognize Promayet again as the violin player seated on the right of *After Dinner at Ornans*, exhibited at the Salon of 1849 and his most revolutionary picture up to that time because it elevated trivial *genre* to the dignity of full-scale figures [47]. It shows a delightfully relaxed moment in Urbain Cuenot's house at Ornans, with the violinist entertaining Courbet himself, his father, and a friend

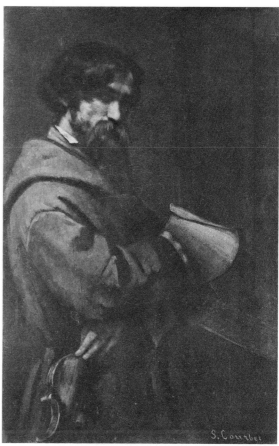

28. Detail of *The Studio*:
Alphonse Promayet

29 *(right)*. *Alphonse Promayet*,
1851. Courbet

Adolphe Marlet, with his Franc-Comtois ditties. He appears once more as a pall-bearer in a broad-brimmed hat in the *Burial* [24], the one furthest away, accompanied by his father the organist, the one in the surplice half hidden behind the curé (not visible in this detail).

Nothing much is known about Promayet, but the few accounts of him that survive reveal him as a most attractive character. Castagnary records that in the early days he would teach music to Courbet's sisters, and encourage them to sing, not of course grand opera, but local songs. He eked out a meagre living as a violinist in the poorer Parisian orchestras. In spite of Courbet's efforts to help him, he was destined to remain poverty-stricken and obscure, sometimes seeking

a hammock behind the screen in Courbet's Paris studio when he lacked a bed. We catch a glimpse of him in the Place de la Concorde during the February days when, in the company of Courbet, Baudelaire and the archaeologist Charles Toubin, he finds himself in the thick of a riot, and a witness to the massacre of an insurgent by the municipal guard. There is no doubt where his sympathies lay. In the spring of 1872 Courbet's sister Zoé appealed to Bruyas to help Promayet who was dying of tuberculosis: 'He is from our province, our very devoted, very much loved childhood friend . . . This is his story: he loved music but because he was poor he was unable to succeed as he would have wished. Poverty forced him to take a post with a family in Russia . . .' A young Russian student was placed in his charge with whom he returned to France. The pupil became a prize scholar. But now he was to be sent to Montpellier to consult specialists. He died shortly after his arrival.[24]

Urbain Cuenot [3U] was another childhood friend, also from Ornans but in contrast to Promayet a prosperous man. They used to hunt together, and in lean years he helped Courbet financially. They made a brief excursion to Le Havre together in 1841 – Courbet's first sight of the Channel. Cuenot sat to the artist for the life-size figure of St Nicholas in bishop's vestments in Courbet's only known religious painting, *St Nicholas Raising the Children from the Dead*, in the style of Zurbarán, for the little parish church of Saule near Ornans (1847). The source for the portrait in *The Studio* is not known to me, but since Cuenot makes no more than an apologetic appearance behind Buchon [32] and in any case is the most summarily treated of the identified characters, possibly no specific prototype was needed. All the same, Cuenot does write to Castagnary ten years later to announce that 'Courbet can do nothing without having his model in front of his eyes'; so perhaps as a local man he consented to pose again on this fresh occasion, or the portrait in the *St Nicholas* sufficed as the model. Courbet's most striking representation of him [30] is a half-length in a floppy broad-brimmed hat, revealing him as the rugged extrovert we

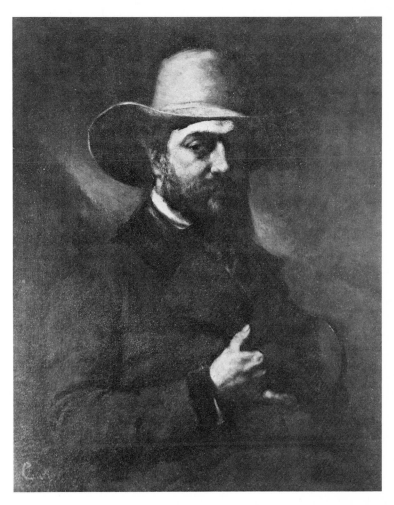

30. *Urbain Cuenot.*
Courbet

imagined – the opposite of Max Buchon, the revolutionary in-
tellectual. His and Courbet's must have been an effortless relation-
ship, nourished by beer and the chase, unruffled by the clash of
abstract ideas.[25]

The third friend of his youth, Max Buchon, was closer to Courbet
in mind and spirit than either of the other two. He came from the
neighbouring town of Salins. They were pupils together at the
Ornans seminary (until 1833), but in those days forged no close
links. It was only later in 1838 when Buchon was at college in

Besançon and Courbet a delinquent outside student there that their intimacy ripened. During the winter of that year Courbet did four lithographs in the current romantic vein as illustrations to Buchon's first book, *Essais Poétiques* (published in Besançon in 1839). They show no marked talent. Courbet was then a boy of 19, Buchon thirteen months older. Throughout the 1840s they were constantly in each other's company both in the Franche-Comté and in the Paris studios and bars, and during Buchon's exile in Switzerland in the following decade Courbet would stop off to visit him on his travels whenever he could spare the time. A few weeks before embarking on *The Studio*, he spent ten days with him in Berne. When separated, they corresponded regularly.[26]

Buchon was brought up most miserably in the Catholic faith by a military father, and we are told he himself had the misleading look of a soldier, as his portrait by Courbet in *A Burial at Ornans* [31], flaunting a jaunty scar on his cheek, confirms. As a young man he fell under the sway of two left-wing political theorists, a fellow-Salinois Victor Considérant, and Pierre-Joseph Proudhon from nearby Besançon, and he became an ardent and active Fourierist, organizing Republican meetings in his district and contributing regularly to local, progressive journals. He was totally dedicated to liberty and the common people; fearless, gentle and the very soul of integrity. Needless to say this got him into trouble with the government as soon as reaction set in. After the failure of the 1848 Revolution he was imprisoned, and again after the *coup d'état* of December 1851 a warrant for his arrest was issued. This time Buchon managed to hide, and eventually to escape to Switzerland where he remained for some six unhappy years before returning to Salins (*c.*1859). The rest of his life was spent in retirement under police surveillance in his native town, where he died ten years later, in Courbet's arms.[27] He always lamented his self-imposed exile, longing to be repatriated, yet too proud to ingratiate himself with the authorities by pleading for forgiveness when there was nothing to forgive. The years in Switzerland had, however, their role to

31. Detail of *A Burial at Ornans*

play, in that he there turned himself into an authority on German folk tales, of which he published translations. He also wrote poems and stories, invariably taking as his subject-matter, like Courbet in the *Burial* and *The Stonebreakers*, Franc-Comtois customs and characters, even though cut off from them by the Bernese Oberland. Thus he could understand Courbet's art from the start of the realist movement more intimately than anyone else, as the celebration of the dignity of man in his local surroundings and at humble tasks, and the revelation of man's misery, as he had the opportunity to prove in his passionate and intelligent defence of the painter in his art criticism of the early 1850s.

When Courbet came to introduce his friend into *The Studio*, Buchon was in exile and so not available for sittings. His portrait [32] is based on one Courbet had started of him, formerly in the Hôtel de Ville at Salins and now in the Museum at Algiers [33], where he is already a little balder than in the *Burial*. He is shown in the Algiers portrait turned to the right, but Courbet has used the

32 *(left)*. Detail of *The Studio*: Cuenot and Buchon

33 *(right)*. *Max Buchon, c.* 1854. Courbet; here shown in reverse

mirror image. Consequently, I also have inverted the image to show how it was used in *The Studio*. This must be the unfinished one referred to in Courbet's letter to Buchon of September 1854 from

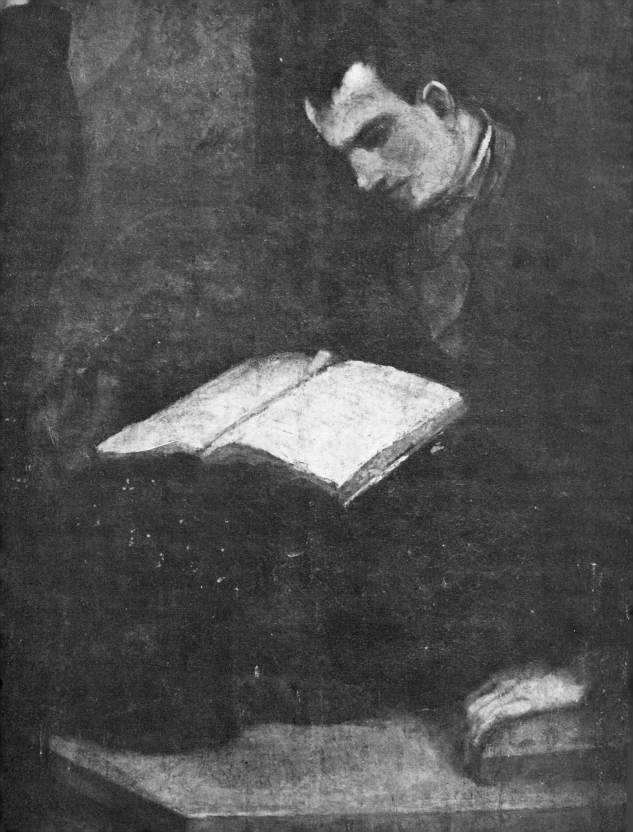

Montpellier in which he suggests that Buchon should write to Courbet's sister at Ornans and ask her to pack it up and send it to Switzerland. Courbet was on the point of visiting Buchon at Berne and agreed to Buchon's suggestion of finishing the portrait there. Whether the picture was ever sent we cannot be sure. At all events, the Algiers portrait was available to Courbet in Ornans the following winter, as a pattern for the new representation. Apart from his introduction into the background of the *Burial* and *The Studio*, no other painted portraits of Buchon by Courbet are known, but in 1864 he did a plaster medallion of him after Buchon's return from exile, as well as one of his wife.[28]

The few remaining personalities, who became Courbet's friends only when he was grown up, are too famous to require biographies, so I shall confine my observations to their relationship with the artist, and to the relevant portraiture. The portrait of Baudelaire [34] is taken straight from one that Courbet had painted of him in the late 1840s when they were constantly together [35] and therefore

34 *(left)*. Detail of *The Studio*: Baudelaire

35. *Charles Baudelaire*, *c.* 1847. Courbet

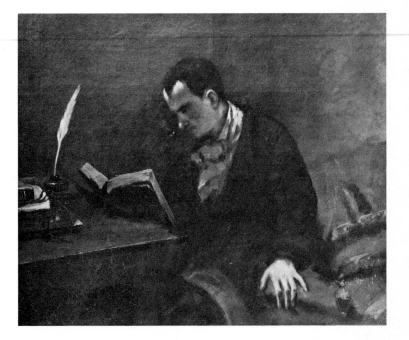

shows him much too young for 1855. Courbet had kept this image by him – out of sentiment, no doubt, not because it recorded a man of genius. It was seen in the rue Hautefeuille in 1859 by Astruc who described it as 'lit in the picturesque manner, which is more or less the poet's spirit'. It was acquired by Bruyas right at the end of his life, and passed from him with the remainder of his collection to the Museum of Montpellier. Courbet had perceived the direction Baudelaire was to take, even in his most active, revolutionary phase: dreamy, out of this world, plunged in the life of books. A green portfolio stands on the table, a yellow dog-eared book, and on top of the pile to complete the day's reading, a brownish book. In its intimacy, in its smudges of light on forehead and nose, in its capture of fleeting life, it anticipates Impressionism by a quarter of a century (or perhaps it would be more prudent to suggest that Impressionism was sometimes latent in late romantic portraiture – and this is the tradition, not that of Realism, to which it belongs). Courbet's own feelings about the impermanence of Baudelaire's features explain the portrait's impressionist look: 'I do not know how to finish Baudelaire's portrait,' he said. 'Every day he looks different.' Here the poet is seated at a table on a red divan; in the more perfunctory version in *The Studio* he is seated *on* the table, for the simple reason that there was no room for the divan. A top hat is parked in front of him. It is always said to be his own, but surely it is more likely to belong to the art collector, who would never visit the studio without one, whereas Baudelaire was an *habitué*. There is no top hat in the Montpellier picture.[29]

Though Courbet sensed it, it cannot have been obvious at the time of the February revolution that Baudelaire's involvement in radical politics and in the realist movement was to be short-lived. Baudelaire was torn between approval of whatever was most modern which happened at that moment to coincide in politics with the liberation of the oppressed and in art with the realistic portrayal of provincial life at its most banal, and his natural inclinations which were towards the exploration of the shadows of the inner life. In the

end the latter had to win. Even during the years with which we are concerned (1848–55) it is possible to trace his gradual turning away from both politics and Realism.

Baudelaire had fought behind the barricades in the February insurrection, and was the chief inspirer of *Le Salut Publique*, a radical newspaper which appeared at the end of February. It had only two numbers, and for the second he asked Courbet for a vignette for the title-page, depicting a scene on the barricades. By the summer of that year he was addressing Proudhon as his 'passionate and unknown friend', and warning him he was in danger of his life. Still in 1852 he was contemplating the foundation with Champfleury of a realist journal entitled *Le Hibou philosophe*, to which only the élite of Realism would be invited to contribute. But by 1855 he could find nothing in him but at best reluctant approval of the movement, and was feeling the need to withdraw from his friends because he knew he no longer belonged to any group. The opposite, Edgar Allan Poe, was meanwhile claiming his heart.

His attitude towards Courbet himself followed much the same course. In his Salon of 1845 he was hoping for the appearance in the following year of a 'true painter' who would 'snatch from the life of today its epic quality', but Courbet who indeed exhibited in 1846 but was in no mood to interpret modern life in such terms, was not the answer to Baudelaire's prayer. He remained silent about the artist until 1855 when, bewilderingly enough, he coupled him with Ingres as lacking in the essential quality of a painter: imagination, that 'Queen of the Faculties'. And in a project for an article that same summer he complained that Courbet had become 'the clumsy Macchiavelli to that Borgia [Champfleury]', and seemed to resent his own introduction into *The Studio* as an undeserved 'honour'.[30] Two years before the publication of *Les Fleurs du Mal*, the truth (that Baudelaire's mind and heart were engaged elsewhere) had to come out. Thereafter their personal relationship deteriorated; and though they met, and spent a convivial evening together, at Honfleur in 1859, there was nothing left to keep the friendship alive.

With Champfleury the relationship was more intimate and of longer duration, though it also had its ups and downs. They had known each other at least since the February days. As the founder and leader of the realist movement in literature, Champfleury marked Courbet down as a potential ally in painting, and was the first, even before Buchon or Sabatier, to come out with his unqualified approval in print. Of a painting still in the late romantic vein, *Walpurgis Night*, which Courbet exhibited at the Salon of 1848 (but subsequently covered up with his *Wrestlers*) Champfleury wrote – though not at all because he perceived the germ of Realism in it, the principles of which had not yet been formulated – 'This unknown artist who painted the *Night*, will be a great painter'; and at the Salon of the following year when the first glimmer of Realism dawned in the shape of *After Dinner at Ornans* [47], reminding him of the heroes of his native town of Laon, the Le Nain brothers, he wrote of Courbet in much the same terms. In 1850 in connection with the *Burial* he first used the word Realism, before even applying it to his own literary productions. In fact, it is odd to consider that it was through the influence of painting that Champfleury was led from romantic Bohemia to a realist outlook; that it was painting and not literature that first launched the word; and it was Courbet's brutal and solid art, not Champfleury's simple a-political tales, that put the stamp of notoriety on the movement.[31]

Champfleury was never able to put his trust in the marriage of art and politics as Courbet was, could never forgive the artist for going off in a political or moralizing direction, believing that art consisted in the mere record of life; and in the early 1850s began to resent the growing socialist influence of Proudhon on the painter. Champfleury saw Realism being led along paths by Courbet that he never intended it to take, which only gave it a bad name. He accused Courbet with some justification (but it was to sidestep the issue) of inordinate vanity, of trying to cajole or scandalize the public instead of remaining faithful to his own temperament: 'I have always told you', he wrote to a correspondent – and it is

instructive to read side by side his growing disillusionment expressed only in letters to friends, and his continuing laudatory pronouncements in the Paris press – 'that, since the *Burial*, our friend has lost his bearings. He has been too much concerned with testing public reaction.'[32] Sour grapes? Champfleury had never succeeded in creating comparable masterpieces in words. His friendship for the painter, eaten up by jealousy, limped on into the 1860s, but was finally poisoned by Courbet's portrait group of the Proudhon family [38] which was more than Champfleury could take.

36. *Champfleury*, *c*. 1853. Courbet

37 *(right)*. Detail of *The Studio*: Champfleury

Already by the time of *The Studio*, relations were strained. Nevertheless, as co-founder of Realism, Champfleury plays a prominent part in the foreground [37], sitting, as Courbet told him in the famous letter, on a stool with his legs crossed and a hat on his knees. The portrait is taken directly from one he had painted about 1853, bequeathed by Champfleury to the Louvre [36]. As usual Champfleury came out with a eulogistic article – like a politician covering up for the bad behaviour of a colleague for the sake of the solidarity of the party they both represent – though he cannot conceal even here a few disobliging remarks; whilst six years later when their relations had worsened, and in contemporary letters to friends, he revealed his true feelings. In 1861 he wrote: 'it even happened to Courbet that he sometimes went completely off the rails, as in the *Interior of the Studio*, which is not a picture but ten pictures'; and in a letter to Buchon he objected to his image in *The Studio*: 'I cannot imagine where he saw me looking like that', though he admits the resemblance is good enough to identify him.[33]

It is sad that none of the three most famous people besides Courbet himself who appear in *The Studio* – Baudelaire, Champfleury or Proudhon – liked the picture at all. Proudhon who was exclusively interested in the social content in Courbet's pictures, and who in his *Du Principe de l'Art* (1865) is always harping on this aspect of his work at the expense of the pictorial which he failed to appreciate, was distressed by the autobiographical element in *The Studio*: 'He is too often concerned with himself, and tends to get puffed up with vanity [on this point at any rate, he and Champfleury saw eye to eye]; what is most reprehensible in his pictures is precisely the intrusion of his own personality. He has painted a purely personal picture in his [*Studio of the Artist*], which is no better than *Lot and his Daughters* [a very early Romantic work by Courbet].'[34] What Proudhon liked best, of course, among the early pictures was *The Stonebreakers* [48], but Courbet only came to acknowledge the full social implications in his own work when Proudhon pointed them out to him; later, with the *Girls on the Banks of the Seine* and

the *Return from the Conference*, painted directly under Proudhon's influence, the social content is more self-conscious.

Proudhon in the early 1850s provided Courbet with what he had failed to obtain from either Baudelaire or Champfleury: a political justification for his Realism, the conviction that he was working for the improvement of society as well as for his own glory. They became fast friends; and in 1853 Courbet would visit him, his wife and children at 83 rue d'Enfer where he had settled after his release from prison. On the posthumous portrait group [38] of *Proudhon and*

38. Detail of
Proudhon and his Family,
1865. Courbet

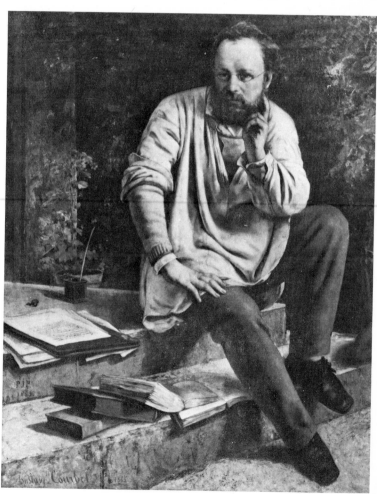

his Family in the garden of this house he has added the inscription 'P.J.P. 1853' on a stone step beside Proudhon's books, in memory of those congenial afternoons before Proudhon's bleak exile near Brussels. But this does not mean that the picture was started at this time, or that studies made for it were used for the group twelve years later – for this there is no evidence. Otherwise one might have expected Courbet to have re-used Proudhon's head for the portrait in *The Studio*, even if in reverse [39]. But as he explains in the first letter to Champfleury, he was hoping Proudhon would come to Ornans to sit to him. Proudhon failed to put in an appearance; so Courbet was obliged to fall back on a lithograph of about 1848 by

39. Detail of *The Studio*: Proudhon

Charles Bazin [40], supplied no doubt by Champfleury who, as we have seen, was asked to look out for one.[35]

He had acquired his three close boyhood friends; his dreamy poet; his fellow-realist in the literary field; his philosopher who showed him the way to his political responsibilities. He still lacked his patron. Apart from a few isolated sales he had managed to negotiate, it was not until the spring of 1853 that he discovered his Chocquet who not only believed in him as an artist (others had done that) but was rich enough to buy his work. The last of the thirty characters in *The Studio*, Alfred Bruyas of Montpellier, was the laurel wreath upon his brow, the prize for seven years of uphill

40. *Pierre-Joseph Proudhon, c.* 1848. Bazin

struggle. All great original artists in the end discover their percipient amateur.

They first met, it appears, at the time of the Salon of 1853 where Bruyas marked down Courbet's *Sleeping Spinner* [49] and *Bathers* [5] for his own collection. He filled his house in Montpellier with paintings by the best modern artists, Géricault, Ingres and Delacroix, and by some charming half-forgotten ones who in the 1970s and 1980s will become household names (all bequeathed by him to the

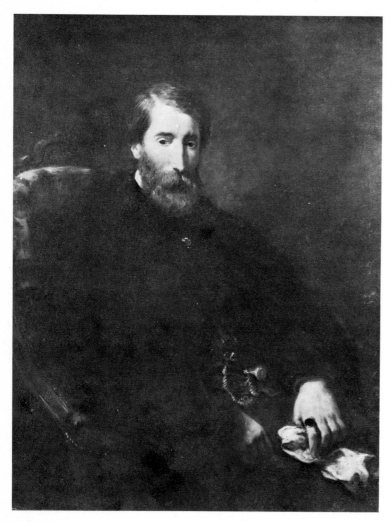

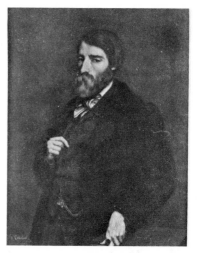

41 *(left)*. *Alfred Bruyas*, 1853. Delacroix

42 *(above)*. *Alfred Bruyas*, 1853. Courbet

Musée Fabre), and was now ready to throw in his lot with Realism though it was still being reviled. This was a gesture, not only of courage but of eccentricity. But then Bruyas was a most eccentric man: a Fourierist, yet also something of a mystic, melancholic, tubercular, narcissistic, frightening his painter friends by his silences, always in delicate health, never willing to reveal himself, yet like many reserved men, suddenly becoming embarrassingly frank, time and again commissioning his own features on canvas. He possessed some twenty portraits of himself, if we count his appearance in groups; once, typically, as Christ crowned with thorns. And always with the same red beard. In 1853 both Delacroix and Courbet were invited to add to the collection of portraits of him. Delacroix was intrigued by the enigma; was at pains to render the romantic distinction that illness lends to a face [41]. Bruyas is shown as the modern counterpart of Michelangelo in his studio, a picture Delacroix had painted three years before and was just then entering Bruyas's collection. Courbet on the other hand was not in the habit of probing deeply into people's inner lives; was happy to gloss over the complexities in Bruyas's character, and to present a more straightforward image with no hint of interesting sickness or distinction of bearing [42]. His portrait parallels their personal relationship. Courbet over-simplified it. For in the letters to Bruyas there is a blustering friendliness which must have suited them both: Courbet because this was his nature, and Bruyas because it helped him to hide behind it.[36]

Soon after the closure of the 1853 Salon we learn from a letter from Courbet to Bruyas that they have the idea of organizing a joint exhibition. Courbet elaborates on this in a further letter to him of January 1854, by which time Bruyas agrees to put up over 40,000 francs. The scheme is to hold a joint show close to the great International Exhibition planned for 1855, of Courbet's paintings and the Bruyas collection. By 3 May, Bruyas acquires a fourth Courbet, the famous *Man with the Pipe*. Courbet then leaves Ornans to spend four months in Bruyas's company in Montpellier. Here he paints

The Meeting [43] showing him, a free man at last, on the road near Montpellier being welcomed by his host who appears with an obsequious servant and a dog, while the *diligence* disappears into the distance. Courbet is loaded up with his painting equipment, ready for a heavy summer's work. So overcome is he by the splendour of the southern skies after the early morning mists of Franche-Comté that he drenches his Montpellier landscapes in sun, like Van Gogh on arrival at Arles. Another, also acquired by Bruyas, shows him greeting the Mediterranean like a lover (*The Sea Shore at Palavas*).

43. *The Meeting*, 1854.
Courbet

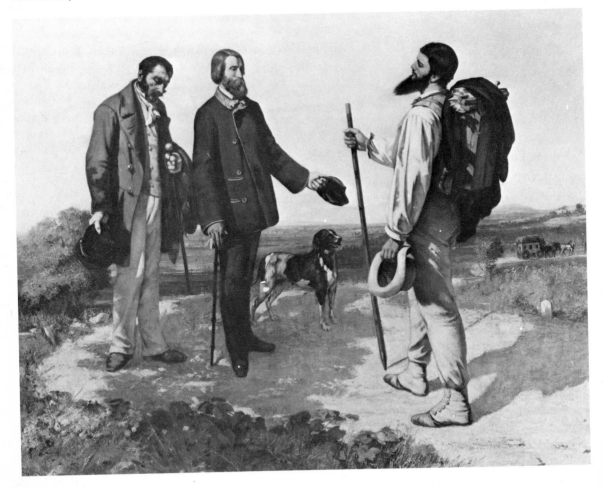

Bruyas commissions two further portraits of himself: one where Courbet gets closest to Delacroix's rendering of Bruyas as pensive and ill, leaning back on a lace antimacassar [45]; the other in profile to the left [46]. These two and *The Sleeping Spinner* must have excited Bazille who spent his boyhood in a neighbouring house. It will be recalled that in the letter to Bruyas of March 1855 Courbet tells him that in *The Studio* [44] he is posed as in *The Meeting*, and this is true to the extent that he wears the same jacket, unbuttoned, and supports his left arm on a stick just as he does his right arm in *The Meeting* (the two portraits, as with Buchon's, being reversed).

44 *(below)*. Detail of *The Studio*: Alfred Bruyas

45. *Alfred Bruyas*, 1854. Courbet

46. *Alfred Bruyas*, 1854. Courbet

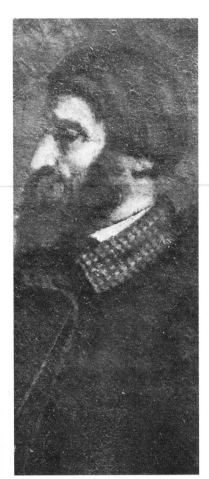

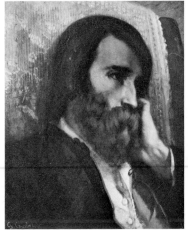

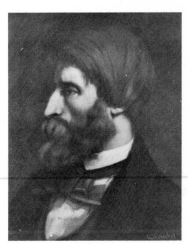

But the head is taken, not from *The Meeting* but from the portrait in profile to the left [46]. Thus Courbet has combined two portraits to compose a third. In the autumn of 1854 he asks Bruyas to send the profile to Ornans, evidently with the object of copying it on to the new canvas. In March of the following year he writes again to say he will not exhibit it, but will return it the next day. He does not need to ask for *The Meeting* because he already has photographs of it to work from.[37]

The happy relationship continues after Courbet's departure from Montpellier, and indeed till the end of Bruyas's life (1877), triumphantly surviving Courbet's disgrace after the Commune. On

his return to Ornans, Courbet writes to say: 'You can count on me on every occasion. When I have made up my mind to love someone, it is for life! . . . I have done justice to your intelligence. Those on earth who have genuine feelings and affections are so rare that you could not have escaped me.' Bruyas silently echoes the same sentiments. The idea of the joint exhibition, it transpires from this letter, has to be abandoned because the money is not forthcoming; Bruyas's father still holds the purse strings. But the letters go on as affectionately as ever.[38]

We have been rubbing our noses too long into the picture, and the time has come to step back again and survey it as a whole. Courbet has given us his word for it that *The Studio* represents 'society at its best, its worst, and its average',[39] so we must expect to find innocuous average people on the left like huntsmen and farm labourers, alongside exploiters (the clergy, corrupt salesmen), exploited (itinerant theatrical performers, undertakers' mutes), and victims of circumstance who are also exploited in the sense that they fall a prey to a vicious social situation (destitute women, ex-revolutionary veterans, unemployed proletariat); just as on the right we must not be surprised to find a pair of average lovers (but love means freedom), an average boy sketching at Champfleury's feet (but his work is not poisoned by art-school training), average rich collectors if that is what they are (but they buy Courbets), alongside some of the most remarkable men of the age, who have been closely involved with the painter in one role or another at different times, shifting his brush a little this way or that, contributing to the unfolding of different sides of his genius, helping to turn him into what he has become, at this moment of mastery as he sits in state at his easel. This much we see. But to see further we must read what other observations he made about his picture, from which an interpretation of its meaning should depart.

'It is the moral and physical history of my studio,' he writes in the long letter to Champfleury, 'it is my way of seeing society in its interests and passions.' To Bruyas he writes: 'here are all the people

who serve me and participate in my endeavour . . . I am hoping to get society to parade in my studio, and so show the public what attracts and what repels me;' more cryptically to his friend Français: 'it's somewhat mysterious. I leave it to those who can guess.' And when the picture was put on exhibition in Paris in 1855 Courbet entitled it in his guidebook, most revealingly of all, 'The Studio of the painter. A real Allegory resolving a phase of seven years of my artistic life'. This takes us back to 1848, the year of revolutions, when Courbet, stimulated by the political events in Paris, first saw his way out of his own romantic past, and embarked on a struggle to usher in a new phase in art, based on the study of nature, in which the dignity of the common people in his own remote province would furnish his subject-matter.

It is instructive to observe how closely Courbet's development as an artist between 1848 and 1855 followed the shifts in the political pattern over the same years. In spite of the hideousness of the June days when radical elements in the government were routed, Courbet at first lost none of his confidence in the emergence of a decent new society, to be matched by that of a new art of which he was the self-appointed herald. Late in 1848 he threw contemptuously aside his romantic youth, in order to embark on *After Dinner at Ornans* [47] which differed from other similar depictions of the 1840s in its life-size figures. It was one of the boldest affirmations since Terborch and Chardin that dignity has nothing to lose from directness of approach and the employment of a trivial theme. This idea was further and more boldly elaborated in the autumn of the following year when he produced his *Stonebreakers* [48], and during the winter of 1849–50, his most revolutionary programme of Realism, *A Burial at Ornans* [1]. In the first, the misery of the human condition is brought home to us by the spectacle of two labourers of his district condemned to a lifetime's futility and destitution. In the second, the mourners at a local, insignificant funeral are strung across the foreground of a harsh Franc-Comtois landscape, each one isolated and self-contained, not as in art as generally understood, but as in

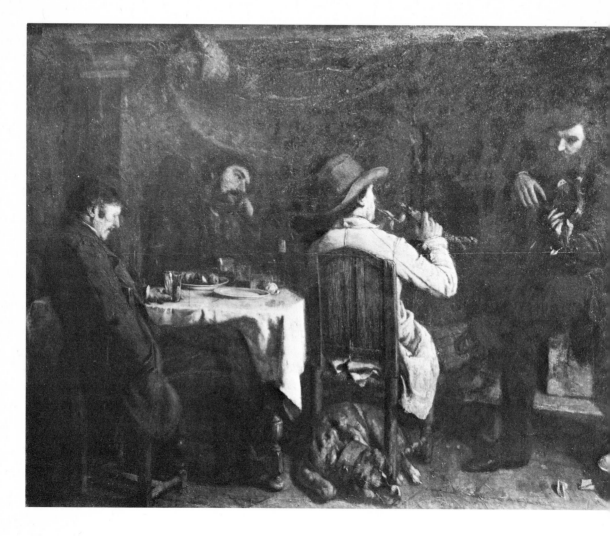

cheap prints. A third picture, ready in time for the Salon exhibition of December 1850, is again gloriously artless: the *Peasants of Flagey returning from the Fair* [4]. What seemed so shocking about these three pictures were the choice of unadorned types, the dead-pan objectivity of approach, and the commiseration with, or glorification of, the uncouth society of a distant countryside. A fourth picture, the *Departure of the Fire Brigade* (Louvre), another trivial scene of everyday life showing Parisian firemen setting out at night to put out

47 *After Dinner at Ornans,*
1849. Courbet

a fire, was begun in the summer of 1851 but significantly left unfinished.

I say 'significantly' because at about the time of Louis Napoleon's *coup d'état* in December 1851 and his enthronement as Emperor twelve months later, Courbet's faith in uncompromising Realism was shaken; or so I deduce from the pictures which immediately

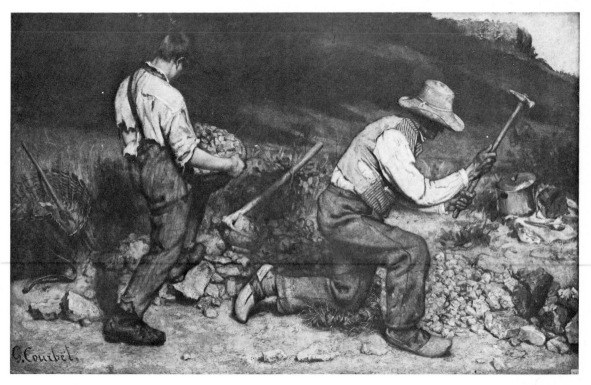

48. *The Stonebreakers*, 1849. Courbet

followed. One of the most striking qualities of *The Stonebreakers*, the *Burial*, the *Return from the Fair* and the *Fire Brigade* is their lack of dependence on the art of earlier times; they belong to the history, not so much of the fine arts, as of popular imagery. But now that reaction in the political field was firmly entrenched, so 'art' was seen to be slinking back into Courbet's work. His three best-known pictures exhibited at the Salons of 1852 and 1853, the *Young Women of the Village* (Metropolitan Museum, New York), *The Sleeping*

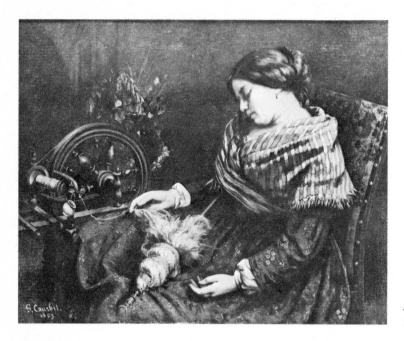

49. *The Sleeping Spinner*, 1853. Courbet

Spinner [49] and *The Bathers* [5] are either more genial, or more firmly rooted in the cultural artistic tradition, or both. The *Young Women of the Village* are no longer rough peasant types but his own graceful sisters dressed in their Sunday best. The model for *The Sleeping Spinner* is again one of these sisters, wearing a flowered dress and a striped shawl, who has charmingly fallen asleep over her distaff – the kind of domesticity which was just growing popular in Victorian England, only differing from its English counterparts in the marvellous sensitivity in the handling of paint. As for *The Bathers*, though admittedly in the curves and creases of the standing bather's back and buttocks Courbet has made an effort to reproduce what he saw, not what the history of art told him to see, the seated bather reminds us not so much of a bather, as of the Florentine Quattrocento – in particular, of Daianira in the Yale Pollaiuolo;[40] while we are astonished to recognize in the allegedly realistic group of *Wrestlers* (Museum, Budapest), also exhibited at the Salon of 1853, the old familiar Renaissance bronze group. Bruyas, whose

taste (one suspects) would not have run to *The Stonebreakers*, was happy to add to his collection of Ingres and Delacroix two of these later, more 'artistic' works.

The source in Pollaiuolo for one of the bathers cannot be established. However, there can be little doubt that the next great picture, *The Winnowers* (Nantes Museum), painted during the winter of 1853-4, is in part based on Velasquez's *Tapestry Weavers*, which Courbet could never have seen, but which was available to him in reproduction. We would never think of searching for sources among the Old Masters in the heroic period of Realism between 1849 and 1851, because we well know it would prove a fruitless task. From 1852 onwards, on the other hand, his submissions to the Salon began to look more like what we mean by pictures, and if the public failed to recognize this fact, this was because they had grown to expect outrageousness from him, and thought they still found it.

This brief survey of 'seven years of my artistic life' has brought us down to the friendship with Bruyas, to the invitation to Montpellier, to *The Meeting* [43], to the series of portraits and self-portraits, and finally to *The Studio* itself. Courbet's retreat from Realism (a word which one senses was already, by 1854, beginning to embarrass him as a label tied too tightly around his neck) culminated in the only solution that now presented itself: an allegory of self-fulfilment.

Here we have a scene quite different from anything in the previous seven years. Here is no 'subject' on the level of work-a-day life. Except for the lovers and the group around the textile pedlar, none of the visitors to the studio participates in any action. There is no communication between them; no event occurs in which they could take part; like the peasants of Le Nain they stare out into space, isolated one from the other – and what else can one expect, considering that they are compiled one by one from earlier, separate likenesses, intended for different purposes, and are stood about like skittles in the spaces allotted to them? I believe it is possible that the idea for this anthology of human beings came to him from the Nadar Pantheon (1851 onwards) which culminated in a vast lithograph (1854)

where all the notable writers of the day are brought together, where the characters are based on earlier sketches and photographs, where there is no contact between people but only a relentless queue of unrelated faces.[41] But there is certainly no visual connection between the two anthologies – only an intellectual one.

Though each one is rendered with astonishing verisimilitude, though one may be captivated by their physical presence so that every drop of an arm or turn of a head clings to the memory, they do not exist as groups, any more than do the characters in *A Burial at Ornans*; and just as in the earlier picture the isolated figures are only united because they partake in a ritual, so in *The Studio* there is nothing to bind them together, except as ideas in Courbet's own mind. They are the symbols of freedom and enslavement, in the shape (the very concrete shape) both of individuals and of types. This is what he means by calling his picture a 'real allegory': the figures, for all their realism, are so many pointers to his own intellectual and moral progress, his way of showing that he has fought his way through corruption and triviality, to emerge, cleansed, in the company of the elect. To us after 120 years this dangerous conjunction of the real and the ideal is no longer so disturbing. But it distressed Courbet's supporters and friends. In a letter to Madame Sand, Champfleury lamented: 'Here are two words [real allegory] that clash; they trouble me somewhat . . . An *Allegory* cannot be *real*, any more than *reality* can become *allegorical*.' And Proudhon objected: 'I have heard Courbet call his pictures real allegories: an unintelligible expression . . . What! he calls himself a realist, and occupies himself with allegories! This wretched style, these false definitions have done him more harm than all his eccentricities; he is a realist, and he is turning back to the ideal through allegory.'[42]

Champfleury and Proudhon, who had coaxed Courbet in two directions, the one to take up a certain artistic, the other a certain political, standpoint: did these two not sense that he was being led away from them towards a third personality, Bruyas, who was offering what he still lacked and what they could not supply, namely

money, and so the power to free himself from dependence for a living on official recognition? Courbet had always been hampered by lack of funds, and now after meeting Bruyas, for the first time he felt a free man. This accounts for the new-found, wonderful confidence of *The Meeting* and *The Studio*. Now he can sit himself down in the centre of his stage and survey his growth culminating in triumph. It has been suggested that he and Bruyas discussed the forthcoming picture at Montpellier the previous summer; and in a cryptic remark in a letter to Bruyas posted just before his arrival there, he seems to be hinting at some such project: 'One more [self-portrait] remains to be done, and that's the man sure of his principles, the free man.' Even if *The Studio* had not by then taken concrete shape in Courbet's mind, even if no such conversations ever took place, there can be no question that it was under the stimulus of Bruyas – who also had an obsessive concern about his own portrayal, who had developed a taste both for the real and for the ideal, both for Géricault's still life of severed limbs, and for pictures which only yielded their meaning when the symbols were unravelled – that he realized that the solemn step to combine the real and the ideal on a single vast canvas was the one he should now take.[43]

One ingenious critic, Linda Nochlin, has wished to go further, and interpret *The Studio* as in part a Fourierist allegory. Her theory is most persuasive. No less than three participants 'on the side of life' were at one time or another acknowledged Fourierists: Buchon, Proudhon and Bruyas (though Proudhon's relations with the movement are ambiguous). Sabatier, if he is really present, was a fourth. Courbet once declared himself to be one. In 1851 he styled himself 'not only a socialist, but also a democrat and republican, in short a partisan of the entire revolution, and above all a realist; that is a sincere friend of the real truth', and by these words he meant complete liberty in the Fourierist sense. Three other participants in *The Studio* had taken an active part in left-wing politics as liberators during the abortive February rising: Promayet, Baudelaire and Champfleury. Unquestionably the allegory is impregnated with

romantic socialism. But we have to be careful not to interpret it too narrowly. The picture strikes me as too personal to meet the requirements of any strict political programme. I am reminded of a phrase of Courbet that Silvestre reports: 'I am a Courbetist, that is all there is to it.' In this case, admittedly, he was referring to his painting, but in politics he was a Courbetist also, too much of an individualist to be dictated to by anyone.[44]

Professor Nochlin believes that an inscription on Papety's drawing of a Fourierist allegory in Sabatier's collection, the *Last Evening of Slavery* (*c.* 1848) was a possible source of inspiration for Courbet's picture. There also exists in the Museum at Compiègne a painting by Papety on the same theme [50]. Courbet may indeed have taken an

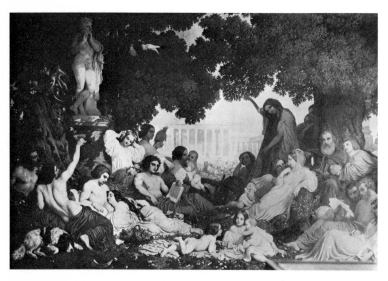

50. *Le Rêve de Bonheur*, 1843. Papety

idea for *The Studio* from Papety, or from what Sabatier and Bruyas reported about him. But between Papety's conception and Courbet's, there is not the slightest affinity, as Professor Nochlin would be the first to admit. For the stylistic sources of Courbet's picture we are obliged to search much further afield.

The one great nineteenth-century artist before Courbet to invest reality with a symbolical meaning, to go beyond real life in order to point a moral and yet to retain a tight hold on the physical facts,

Géricault, is no help stylistically, although in spirit Géricault is closer to him than any of his immediate predecessors. Velasquez is little help either, although so often invoked as an ancestor of *The Studio* because he painted a vast picture with groups of people in which the artist himself plays a prominent part. What has misled critics is that Courbet did borrow from Velasquez a pose for his *Winnowers*. But the evanescence of *Las Meninas* has nothing in common with the aggressive physical presences of *The Studio*. Much typewriting ribbon has also been wasted on the search for sources in nineteenth-century and earlier representations of studio interiors. Naturally Courbet could not fail to know these, and indeed in Bruyas's house the previous summer he was in daily contact with a

51. *Interior of a Room in Bruyas's House*, 1848. Glaize

painting by Glaize [51], showing a room in Bruyas's house where host and guests admire a canvas on the easel. But none of the hundreds of examples of this *genre* has any direct bearing on *The Studio*.[45] The true sources lie in the Netherlandish seventeenth century.

It is hard to get away from the theory that has been put forward, that Courbet was impressed by Rembrandt's *Hundred Guilder Print*, especially since it is cited in Dumesnil's treatise on Rembrandt's religious faith, published in Paris a mere five years earlier. In this treatise Dumesnil points out that the Pharisees and philanthropists are ranged on one side, while on the other are the people of Christ. Here, surely, was one source for the iconography if not for the style of *The Studio*.[46]

It is also not permissible to dismiss as a coincidence the appearance in the foreground of another famous Rembrandt etching,

52A. *Christ Preaching the Remission of Sins*. Rembrandt

52B. Detail of 52A

showing *Christ Preaching the Remission of Sins*, known as 'La Petite Tombe', of a child sprawling on the ground and tracing shapes with his finger in the dust [52], taking no notice of what is going on, any more than does the child at Champfleury's feet in *The Studio*. But though we may be struck by analogies in Rembrandt's etchings on New Testament themes, no specific prototype for the style of *The Studio* has been pin-pointed. One is instinctively driven to search for it in Netherlandish group portraiture.

Courbet once confessed to Silvestre an admiration for a minor Fleming, Craesbeeck, and it has accordingly been suggested that there exists a connection between *The Studio* and Craesbeeck's *Interior* which Courbet could have seen in the Louvre. I suspect that he was more impressed by some such *Artist's Studio* as that in the Institut Néerlandais, Paris [53], where the setting is as stark as in Courbet's *Studio*, [47] where the artist and his friends are portrayed in more natural poses than in the Louvre Craesbeeck. But even this picture is a little too delicate for Courbet's taste, and one may be forgiven for hesitating to claim it as the fountain-head of his inspi-

53. *The Artist's Studio.* J. van Craesbeeck

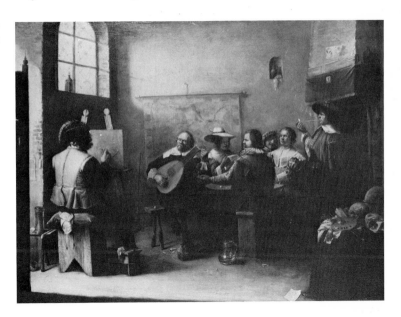

ration. The search for prototypes is seldom rewarding. In the end we are forced to fall back on a masterpiece, bold and uncompromising, in which no specific parallels can be traced as the true spiritual ancestor of *The Studio*: Rembrandt's *Night Watch*.

The rest of the story can be briefly and sadly told. After the demise of the Courbet–Bruyas project, the painter saw no alternative but to throw in his lot with the authorities, and offered his new picture

for display at the International Exhibition due to open in the spring of 1855, along with *A Burial at Ornans* and a number of other works. To his fury, both vast pictures were rejected by the jury, as well as the portrait of Champfleury [36]. To do the jury justice, the rejection of *The Studio* and the *Burial* may well have been partly due to lack of wall space. But Courbet saw it as a plot to exclude him, and at once laid plans to hold a one-man show where the two pictures would form centre pieces, as they now do at his end of a room in the Louvre. He agreed to exhibit eleven smaller pictures at the International show that had been accepted, but craftily gave orders for the erection of a temporary shed in the avenue Montaigne on a site adjacent to the official premises, where no less than forty pictures and four drawings were displayed. Above the entrance to the building was the subversive notice: 'Realism, G. Courbet'. The one-man show was a near disaster. Few came to it; those who did laughed. And none of the innumerable notices in the press were willing to pay him more than a grudging tribute. Alone Delacroix, who had been impressed by the vigour of his *Bathers* and *Sleeping Spinner* at the Salon two years before, wrote with understanding in his *Journal*:

'I remain [there] alone nearly one hour and discover a master-piece in the picture that has been refused [*The Studio*]; I was unable to tear myself away from it. It shows enormous progress, yet at the same time it helped me to admire the *Burial* . . . In the [*Studio*] the spaces are well organized, one can breathe air, and there are parts of it well executed: the hips, the thigh of the nude model and her throat; the woman in front with a shawl. The only fault is that in the picture he is painting there is an ambiguity: one has the impression of a *real sky* in the middle of the picture. They have rejected one of the most remarkable paintings of our times; but [Courbet] is too sturdy to be discouraged by so slight a setback.'

This verdict, which ignores the subject-matter, is at the opposite pole to Proudhon's.[48] But a painter's enthusiasm for the quality of paint, and a philosopher's indifference to it, are not confined to the twentieth century.

Courbet took the picture back to the rue Hautefeuille, rolled it up, never retouched it, and allowed it to collect the dust. Thereafter it was only exhibited twice during his lifetime, at Bordeaux and Vienna. It was not sold until 1881 after his death, and appeared in the following year in the great retrospective exhibition. In 1897 when it was again up for sale the warmest tribute since Delacroix was paid to it: Degas bid for it. But it was not until 1920 that a subscription was raised for its acquisition by the Louvre. Since then it has taken its place in the mainstream of European art, half way between the *Raft of the Medusa* and *La Grande Jatte*, and it is only with the exercise of considerable historical imagination that we can now recapture the courage and impertinence that went to its making.

Appendix I
Chronology of Events

There is so much confusion in the literature about the actual sequence of events in these crucial years in Courbet's career (1853–5), that it is desirable to sort it all out as far as possible in an Appendix. If some reasonably secure dates can be established, the story becomes clearer. The trouble is, writers seldom consult all the literature, and so miss essential points.

The first problem arises over the date of the famous lunch with Nieuwerkerke, as described by Courbet from Ornans in a letter to Bruyas at Montpellier.[49] This is generally dated December 1854 though a few writers have agreed to place it a year or so earlier. One would think that the matter would be settled once and for all by the fact that Bruyas himself in 1854 dates it in the previous, not the current, year,[50] but this fact has passed unnoticed. A date over a year earlier suddenly makes better sense for the following reasons. The undated letter from Silvestre to Bruyas mentioned in it, to which Courbet adds a postscript, is the one in which Silvestre says he is sending Bruyas the first two volumes of his book (published 1853).[51] *The Bathers* was in the Paris studio, so the 1853 Salon had already closed. Chenavard and Français had received the Cross of the Legion of Honour in the late summer of 1853. A major art section as part of the Universal Exhibition of 1855 had already been announced in the summer of 1853 (as 1854 was to be skipped) and Nieuwerkerke was to be President of the admission jury. The latter in the late summer of 1853 asked Chenavard and Français to put him in touch with Courbet. He would have been anxious to obtain Courbet's cooperation before the first meeting of the Imperial Com-

mission of Fine Arts on 29 December 1853. It is absurd to suppose that he would postpone this meeting until a few months before the exhibition opened. We cannot fix the date of the letter quite precisely, but the facts given above (as anyone who reads the letter again will understand) point to about October 1853.

The letter to Bruyas from Ornans about the *Winnowers* and the *Man with the Pipe*[52] is dated by Bruyas[53] January 1854, in the very year in which he published it. In fact it is possible to arrive at this date from internal evidence, as I did before coming on Bruyas's date. The *Winnowers* was painted at Ornans during the winter of 1853-4 and finished in Paris at the beginning of 1854. The *Man with the Pipe* was sent to an exhibition at Frankfurt early in 1854 and the Russian Minister there offered to buy it. In a letter to Bruyas dated by Bruyas 3 May 1854[54] Courbet writes that he is unwilling to let the Russian Minister have it, that it is now back and belongs to Bruyas, and that he will bring it with him to Montpellier.

In this letter he says he hopes to be with Bruyas in just over a fortnight. Bruyas[55] in that year writes that Courbet spent from May to September with him, so he arrived in Montpellier towards the end of May. His family had still not heard word of him by 17 June. His sister Zoé writes to Bruyas on that day from Ornans complaining of lack of news.[56] In a letter to Zoé[57] evidently written a little later than hers to Bruyas, Courbet asks her to reassure their father about his finances. In Courbet's letter of the 13th of *a* month to Buchon from Montpellier,[58] he says he hopes to be in Berne on the 15th, 18th or 20th at latest, and to visit Buchon on his way back to Ornans. This we now know to be September. A letter to one of his clients from Montpellier dated 18 September[59] shows that he had still not left then, but must have done so within the next week.

In a letter from Zoé Courbet to Bruyas dated from Ornans 6 December 1854[60] she says she had waited to write in order to join her letter to her brother's, and that he would write to Bruyas soon. This enables us to date Courbet's next letter to Bruyas,[61] in which he mentions the receipt from Bruyas of some photographs and the

commencement of *The Studio, just as Zoé does*, about this time. In it he describes what he has been up to since he left Montpellier. On leaving Montpellier he had at least a fortnight travelling about, which brings us to about the second week in October. On his return to Ornans he spent a few days hunting, but was suddenly struck down by jaundice. He remained over five weeks without leaving his room. His illness must therefore have lasted from the second part of October to about the end of November.

Zoé in her letter says Courbet is recovering and at last able to get down to *The Studio*. Courbet in his approximately contemporary letter to Bruyas provides him with more details about the new picture, saying he gives himself two and a half months for its execution, but that he has to go to Paris to do some nudes.

If he had been able to keep to his schedule of about mid or late February 1855 for the completion of the picture, there would have been no need to apply for an extension, since the picture would have been in time for handing in before the middle of March; but his travels that winter (about which we are ill-informed) kept him longer away from his easel, or the execution of the picture took longer than he anticipated, or both, with the result that he was compelled to write to Français[62] to plead on his behalf with Nieuwerkerke for a postponement of ten days to a fortnight. He says he has been at work on *The Studio* for a month and only has one month left, which is too short. He writes to Bruyas[63] after he had been granted his extension to say that the final dates for handing in were 29 to 30 March, so the letter to Français must be dated at least six weeks earlier, that is about the beginning of February.

A letter from Champfleury to Buchon dated 6 February 1855[64] informs us that Champfleury had heard of Courbet's progress indirectly, that he already knew about the 'large and strange picture', which was going on so slowly that Champfleury feared he would not have it ready in time for the exhibition. Champfleury must have heard from the painter directly by this time (? end of January) because it is clear from Courbet's long description of the

picture to him,[65] with references to features in it which were subsequently eliminated, that it was still at a comparatively early stage.

From a second letter from Courbet to Champfleury of 3 March[66] we learn that he had still not had his extension. He proposes to be in Paris at the beginning of April. The picture is still unfinished. He has still to write to Bruyas for *The Meeting*, the *Man with the Pipe* and the *Self-Portrait in the Striped Collar*. Three days later Champfleury reports to Buchon the receipt of this second letter.[67] The letter to Bruyas announcing a fortnight's grace[68] follows closely on the one to Champfleury because he here asks for these very pictures to be sent to Paris, and time is pressing. Only four or five figures are to be added to *The Studio* – another ten days' work or so, taking us down to about the third week in March.

From then onwards the sequence of events is easier to establish. The jury is installed on 19 March. Courbet and the remainder of his pictures arrive in Paris before the end of the month. The *Burial* and *The Stonebreakers* are already there. On 6 April Richard Redgrave sees *The Studio* in one of the exhibition halls (see Appendix II). By 11 April the jury agrees on its selection. Three days later Champfleury writes to Buchon[69] to complain of his own portrait in *The Studio*, which he has now seen. Courbet must have heard about the middle of the month that his two big pictures, the *Burial* and *The Studio*, and the portrait of Champfleury, had been rejected, and decided, as he writes to Bruyas from Paris,[70] to go ahead with the one-man show. This letter cannot have been written before the middle of May when the exhibition opened because Courbet describes how the pictures that were accepted are being well received by the public. On 26 April he had received authorization for premises at 64 rue Amelot,[71] but subsequently changed his mind, preferring to be alongside the Universal Exhibition itself. It is the authorization for these new premises that, as he reports to Bruyas, he is now negotiating. He has almost completed the formalities. The contract for the new gallery was signed on 16 May. The one-man show opened at 7 avenue Montaigne on 28 June.

This leaves one letter from Courbet to Bruyas unaccounted for.[72] Since he mentions in it a recent visit to Montpellier where Bruyas had entertained 'us' so charmingly, I suspect it belongs to 1857 when Courbet visited Bruyas in the company of Champfleury, Schanne and Soulas.[73]

Appendix II
Redgrave's Reaction to The Studio

Richard Redgrave noted the following in his Journal on 6 April 1855 (published in *Richard Redgrave, C.B., R.A. A Memoir; compiled from his diary*, by F. M. Redgrave, London, 1891, pp. 126–8). The last paragraph was of course added later, since in April there was no question of a separate exhibition in the vicinity. The passage was brought to my attention by Francis Haskell.

'Some of the pictures here by Frenchmen of celebrity surprise me greatly. I have seen today, standing in one of the vast halls, a work by Courbet. He is a great man, and they hardly know how to deal with it. It has, I hear, been once rejected, but the discussion is renewed at the instance of his friends. I can hardly trust myself to say what I think of its coarseness of conception, of execution, and design. It represents an interior, I presume the painter's studio. He is sitting at his easel, on which is a large landscape, and he seems about to introduce into it a naked figure, perhaps as a bather. The studio is filled with male friends and pupils of the artist, but the principal figure in the foreground is a strong-minded woman [the collector's wife], amidst a group of gentlemen. I say "strong-minded", for immediately in front of her, and standing between her and the picture, is a female model, most common in form, who holds up some drapery before her in such a way as to make her nakedness more visible. At the feet of the strong-minded female is a small boy, about fourteen years of age, lying on the ground, with a sheet of paper, on which he is sketching the model. All this is bad enough, but at the foot of the easel is another sitter, a coarse, fat,

greasy beggar woman, almost entirely without drapery, engaged in nursing a dirty little brat. All these figures are the size of life. A beggar-child in front of the easel, about eight years old, is looking at the naked bather before described. Nor is this sufficiently strong for French taste, or as a picture of "studio doings". Behind the easel, apparently posed for one of the pupils, is an undraped *male* model! [the lay figure]. The room, as I have said before, is full of friends, bearded and hoary, as well as the lady devoid of unnecessary delicacy. In the background is a young female model who has just, I presume, completed her toilette, upon which a pupil is complimenting her with a kiss [the lovers]. Dogs of various breeds complete the picture. The whole is wrought with the execution of a house-painter who has just taken up art. It is bad both in form and in colour. Truly this is a strange people! Side by side with this work, a picture of our Lord's Agony or of the Blessed Virgin will probably be hung!

'One new rendering of the Annunciation I saw in close proximity to the Courbet, a really beautiful work by Jalabert, refined in drawing, in feeling, and in taste.

'The picture by Courbet, after many discussions, was taken down and returned, which so nettled him, that, although he had many other pictures hung, he opened a separate exhibition in the vicinity.'

Acknowledgements and Bibliography

I have had help from many people, but to Hélène Adhémar, Alan Bowness and Robert Fernier I am indebted for essential photographs or documents.

The following publications have proved the most useful. I cite them in the notes to the text by shortened titles, as here shown in brackets. Other publications are given in the text in full. The specialist is referred to another detailed study of *The Studio* which is not cited in my text: the pamphlet by Bert Schug, *Das Atelier*, Stuttgart, 1962.

Explication des Ouvrages de Peinture du Cabinet de M. Alfred Bruyas, Paris, 1854. (Bruyas, 1854)

Théophile Silvestre, *Histoire des Artistes Vivants, Etudes d'après Nature*, Paris, 1856. (Silvestre, 1856)

P.-J. Proudhon, *Du Principe de l'art et de sa destination sociale*, Paris, 1865. (Proudhon, 1865)

La Galerie Bruyas par Alfred Bruyas, Paris, 1876. (Bruyas, 1876)

Jules Troubat, *Une Amitié à la d'Arthez*, Paris, 1900. (Troubat, 1900)

Georges Riat, *Gustave Courbet, Peintre*, Paris, 1906. (Riat, 1906)

Emile Bouvier, *La Bataille Réaliste*, Paris, 1914. (Bouvier, 1914)

Courbet selon les Caricatures et les Images. Documents réunis et publiés par Charles Léger, Paris, 1920. (*Caricatures*, 1920)

Charles Léger, *Courbet*, Paris, 1929. (Léger, 1929)

Journal de Eugène Delacroix, André Joubin, ed., 3 vols., Paris, 1932. (*Delacroix Journal*)

Meyer Schapiro, 'Courbet and Popular Imagery', *Journal of the Warburg and Courtauld Institutes*, IV, 1940-42, pp. 164 ff. (Schapiro, 1940-42)

René Huyghe, Germain Bazin, Hélène Adhémar, *Courbet L'Atelier*, Paris, 1944. (Adhémar, 1944)

Les Amis de Gustave Courbet - Bulletin, Paris-Ornans, 1947 onwards. (*Bulletin*, followed by number of issue)

Charles Léger, *Courbet et son Temps*, Paris, 1948. (Léger, 1948)

Courbet raconté par lui-même et par ses Amis, 2 vols., Geneva, 1948 and 1950. (*Courbet raconté*, 1948, 1950)

Gerstle Mack, *Gustave Courbet*, London, 1951. (Mack)

Lettres de Gustave Courbet à Alfred Bruyas, publiées par Pierre Borel, Geneva, 1951. (Borel, 1951)

Aragon, *L'exemple de Courbet*, Paris, 1952. (Aragon, 1952)

Werner Hofmann, *Art in the Nineteenth Century*, London, 1961. (Hofmann, 1961)

Matthias Winner, 'Gemalte Kunsthistorie', *Jahrbuch der Berliner Museen*, 1962, pp. 151 ff. (Winner, 1962)

Aaron Scharf, André Jammes, 'Le réalisme de la photographe et la réaction des peintres', *Art de France*, IV, 1964. (Scharf/Jammes, 1964)

Max Kozloff, 'An Interpretation of Courbet's "L'Atelier"', *Art and Literature*, 3, 1964, pp. 162 ff. (Kozloff, 1964)

Robert L. Alexander, 'Courbet and Assyrian Sculpture', *Art Bulletin*, 1965, pp. 447 ff. (Alexander, 1965)

Linda Nochlin, 'Gustave Courbet's *Meeting*: A Portrait of the Artist as a Wandering Jew', *Art Bulletin*, 1967, pp. 209 ff. (Nochlin, 1967)

Linda Nochlin, 'The Invention of the Avant-Garde', *Art News Annual*, XXXIV, 1968, pp. 11 ff. (Nochlin, 1968)

Catalogue of the Baudelaire exhibition, Petit Palais, 1968-9. (Baudelaire, 1968-9)

Robert Fernier, *Gustave Courbet*, London, 1969. (Fernier, 1969)

Catalogue of the Courbet exhibition, Rome, 1969-70. (Rome, 1969-70)

Linda Nochlin, 'Gustave Courbet's "Toilette de la Mariée"', *The Art Quarterly*, Spring 1971, pp. 31 ff. (Nochlin, 1971)

Alan Bowness, 'Courbet's Atelier du Peintre', Charlton Lecture, Newcastle upon Tyne, 1970. (Bowness, 1972) (only available in MS.)

Notes

For full bibliographical references throughout these notes given by short-ened titles, see the Bibliography, pp. 83-4.

1. *The Studio* is dated 1855. A detailed analysis of the sequence of events leading up to its exhibition will be found in Appendix I to this study. Courbet seldom dated his letters, so one is forced back on internal evidence to determine when they were written. In this, the main body of the text, I take the dates for granted, though the analysis in the Appendix will show that they are sometimes speculative.

2. The size of the picture is 359 x 598 cm. These are the dimensions as given to Champfleury, but also (which is more significant) the dimensions as given to Bruyas when he was starting on the picture in late November or early December 1854 (Borel, 1951, p. 50). This proves that the two successive additions to the canvas were made *before* he started. It cannot be deduced that he changed his mind on the format at any stage in the execution. I cannot therefore agree with Nochlin, 1971, p. 47 that Courbet decided to enlarge his canvas in order to supply a more ample setting to account for the diminution of the background figures. The original canvas was 275 x 500 cm. – that is, the bottom right-hand area. He then added about 83 cm. above with a new strip, and finally a coarser strip on the left running to the top (this is how we know it was added last) about 95 cm. wide (see Adhémar, 1944, p. 8).

3. I have adopted with changes and additions the English translation given by Mack, pp. 128-30, from the original French which has been frequently quoted. Bowness's English version (1972) also differs slightly from Mack's, and this also has assisted me in clarifying Courbet's meaning.

4. The two letters to Bruyas are in Borel, 1951, pp. 47 ff. and p. 61 respectively. For the letter to Champfleury, see Léger, 1948, p. 54.

5. There is some doubt as to whether the *Return from the Fair* at Besançon is the one Courbet exhibited at the Salon of 1850-51. For a full discussion of the problem, see Rome 1969-70 under no. 11.

6. To judge by the reproduction of *The Studio* in the catalogue of the Desfossées Sale, 26 April 1899 (20), the background strips have since become more pronounced.

7. The picture was formerly in the Collection of Jules Paton; sold Hôtel Drouot, 24 April 1883 (see Léger, 1948, p. 199).

8. For further details, see Adhémar, 1944, pp. 9, 14; and Baudelaire, 1968-9, Nos. 226 and 280, and editorial note p. 70.

9. The description is Castagnary's on his first visit to the studio in 1860 (see *Courbet raconté*, 1948, pp. 142 ff.). Some of this information about Courbet's studio comes from Henri Baillière, *La Rue Hautefeuille*, Paris, 1901, pp. 330-56.

10. See Alexander, 1965, p. 447. Alexander, however, goes too far in suggesting that Courbet was actually influenced by the Assyrian reliefs.

11. The quotation is from Silvestre, 1856, pp. 242-3. The three caricatures mentioned are reproduced in *Caricatures*, 1920, pp. 28-9, and 39. There are many comparable examples.

12. The Lalane and Defonds photograph reappeared as a lithograph by Masson in Silvestre, 1856 (see Aragon, 1952 as frontispiece). The photographs by Durand et Cie and Pierson are reproduced by Fernier, 1969, p. 411. The Radoux photograph is reproduced in *Bulletin*, No. 15, p. 20. I am too uncertain of the dates of other famous photographs of Courbet in the 1850s to be able to deduce from them evidence of his change of appearance.

13. The phrase from the letter to Buchon is quoted in *Bulletin*, No. 5, p. 23; to Bruyas, in Borel, 1951, p. 50.

14. The two passages in the letters to Bruyas are in Borel, 1951, pp. 52, 59, 61.

15. In a letter to Castagnary about 1872-3 from Ornans, Courbet describes how his studio had been used as a barracks for French soldiers, and included a sketch for *The Studio* among the list of works stolen (Léger, 1929, p. 172). The 'preparatory' drawing described by Léger, 1948, pp. 53-4, supposedly signed and dated 1855 (which is a year too late), is not autograph, so M. Robert Fernier informs me.

16. The tracing which was found in Courbet's studio and later belonged to Matisse, was exhibited at the Courbet exhibition, Galerie Claude Aubry, Paris, 1966 (38). It is on tracing paper, in thick ink, repeated in pencil on the reverse, and measures 47 x 31 cm. A similar outline intended for transfer of a figure out of the *Girls on the Banks of the Seine* was also exhibited (No. 39).

17. The two double portraits are reproduced in Frederick Antal, *Hogarth and his Place in European Art*, London, 1962, plates 128a and 129b. There is also a self-portrait of an artist at his easel by Desmarées (1760), inspired by his daughter behind his chair, illustrated in Antal, plate 128b.

18. The identification was first made by Scharf/Jammes, 1964, p. 181 (see also Scharf, *Art and Photography*, London, 1968, pp. 98–9). This photograph by Jules Vallou de Villeneuve is registered at the Bibliothèque Nationale in 1854.

19. Silvestre, 1856, p. 245.

20. The quotation from Castagnary is from the Courbet papers, B. N. Estampes. The testimony of Buchon is contained in a letter to Castagnary of 20 February 1866, published in *Courbet raconté*, 1948, p.206. Courbet himself maintained that Oudot was 83 in 1848 (undated note in Courbet's hand among Courbet papers, B. N. Estampes, quoted in *Courbet raconté*, 1950, p. 49).

21. The whole subject of the left-hand side of the picture (and indeed of the centre and the right) has been exhaustively treated by Adhémar, 1944, p. 18, and I have drawn heavily on this passage. I only disagree with the positive identification of 2F as a third huntsman; with that of the labourer's wife (2L) as a prostitute (although admittedly one expects to find one in this *galère*); and that of the *croque-mort* (2K) as Oudot. The huntsman in the foreground is described by some writers as a poacher, but there does not exist the evidence to identify him with this romantic, anti-authoritarian figure, sympathetic to Courbet. I am unable to follow Kozloff (1964, p. 169) and Nochlin (1967, p. 215) in their supposition that Courbet's drawing in the Louvre of a mother and her child (illustrated in Aragon, 1952, plate 87 along with other figures on the same sheet) was used for the Irishwoman and her child in *The Studio*. The group in the drawing is much too well dressed.

22. The suggested identification was first made by Nochlin, 1968, p. 14. On Sabatier, see the article by Jean Claparède in *Bulletin* No. 7. Seurat could have seen *The Studio* at the retrospective exhibition of 1882 – this was his only chance.

23. Quoted Riat, 1906, p. 342. Courbet's bust portrait of Promayet was formerly in the collection of André Derain. A beautiful Courbet black chalk drawing of Promayet, full face, dated 1847, is illustrated in Aragon, 1952, plate 4.

24. The testimony of Castagnary is quoted in *Courbet raconté*, 1948,

p. 87. The episode in the Place de la Concorde is recounted by Charles Toubin, *Souvenirs d'un Septuagénaire, Revue des Deux Mondes*, 1 March 1925 and 15 October 1926. Zoé's letter is published in Mack, pp. 296-7. The Courbet papers, B. N. Estampes include a copy of a letter from Courbet to Bruyas of 1 March 1873, thanking the latter for his kindness to Promayet.

25. Details about the *St Nicholas* will be found in *Bulletin* No. 4, pp. 15 ff. Cuenot's letter to Castagnary dated from Ornans 22 February 1865 is in Courbet papers, B. N. Estampes. Adhémar, 1944, p. 16 notes a black chalk drawing by Courbet of Cuenot dated 1850, and the catalogue of the Rome exhibition, 1969-70, under No. 25, p. 59 notes a posthumous portrait (1868). The black chalk drawing is presumably the occasion of the dispute between Courbet and Cuenot's brother-in-law (see the latter's letter to Courbet dated 15 May 1868 among Courbet papers, B. N. Estampes). The brother-in-law claimed that Cuenot had paid Courbet 400 francs for his portrait and a small landscape, and that among Cuenot's papers after his death had been found a receipt from Courbet for this sum dated 1850. Courbet denied that the receipt referred to this transaction, and that he had ever received this sum. The brother-in-law asks for either the portrait, or the money. One suspects the brother-in-law was in the right.

The head-and-shoulders so-called study for the Pennsylvania portrait in the Ornans Museum is in my opinion not by Courbet, but must have been copied later from the half-length. It shows Cuenot hatless. This is not surprising considering that the Philadelphia picture only acquired a hat in the twentieth century. Fernier, 1969, pp. 73-4 notes a caricature dating from the time of the exhibition of the Pennsylvania picture at the 1848 Salon showing Cuenot hatless, but I have not seen this. If Fernier is right about the date, then this is a sensible reason for obliterating the hat again.

26. For the early relations between Courbet and Buchon, see letter from Buchon to Castagnary, 20 February 1866, in *Courbet raconté*, 1948, pp. 206 ff. The lithographs are reproduced in Léger, 1929, p. 25.

27. The military aspect is commented on by Champfleury in his introduction to Vol. I of Max Buchon, *Poésie*, Paris, 1877-8, p. vii. A highly coloured account of Buchon written under the stress of grief is given by Courbet himself in a letter to Castagnary from Salins of 16 December 1869, see *Courbet raconté*, 1950, pp. 116 ff. I have also profited from a warm-hearted obituary by Daniel Rueff in *Le Doubs*, 18 October 1869.

28. The letter from Courbet to Buchon from Montpellier is published in *Bulletin* No. 5, pp. 22–3. A letter published in *Bulletin* No. 21, pp. 6–7 from Courbet at Salins to Proudhon of 8 December 1864 mentions the two plaster medallions. The well-known full-length portrait in the Museum of Vevey does not represent Buchon. Nothing is known of its history until it turned up in a bric-à-brac shop in the early 1880s. Claudet, Buchon's closest friend, denied it represented him, and so did Cuenot's brother-in-law L. Proudhon (see catalogue of the Rome exhibition, 1969–70 (29)). L. Proudhon also seemed to be doubtful about the attribution – in my opinion justifiably. It is quite unlike anything else in Courbet's work, and seems to belong to a later generation of the late 1860s or even 1870s.

29. The quotation from Astruc is taken from Riat, p. 170; that from Courbet is from Champfleury's *Souvenirs et portraits de Jeunesse*, see *Courbet raconté*, 1948, p. 80.

30. Courbet's vignette for *Le Salut Publique* is reproduced in *Bulletin* No. 3. The quotations from Baudelaire's *Salons* are taken from *The Mirror of Art*, ed. Jonathan Mayne, London, 1955, pp. 38, 203. For the letter to Proudhon of 21 August 1848, see Baudelaire, 1968–9 (218). It is not at all clear from Baudelaire's notes (discovered by Jacques Crépet; see Adhémar, 1944, p. 24), that he is referring to his own appearance in *The Studio*, but this is what one assumes from the context. The inscription to Baudelaire and date 1859 on a flowerpiece in the Basle Museum attributed to Courbet is most suspicious (as Francis Haskell has shown, *Burlington Magazine*, March 1969, p. 173).

31. Champfleury's praise of Courbet is to be found in *Pamphlet*, 28 September 1848, *La Silhouette*, 22 July 1849, and *L'Ordre*, 21 September 1850. Bouvier, 1914, pp. 233–4 sensibly suggests that Champfleury was put wise to Courbet's talents by Buchon. My general remarks about realism in painting and literature are indebted to Bouvier, pp. 244–5.

32. Undated letter (? *c.* 1856) to an unknown correspondent, quoted *Courbet raconté*, 1948, p. 131. See also the letters to Buchon complaining of Courbet, in Mack, pp. 139 ff. The best account of Champfleury's rejection of politics is in Schapiro, 1940–42, pp. 184 ff.

33. The Louvre portrait is wrongly dated 1855. Champfleury's remarks about *The Studio*, in *L'Artiste*, 2 September 1855, are quoted by Adhémar, 1944, p. 25. The quotation of 1861 is from *Grandes Figures d'Hier et d'Aujourd'hui*, Paris, 1861, p. 258. The letter to Buchon is quoted by Léger, 1948, p. 55 and Mack, p. 132.

34. The quotation about *The Studio* is from Proudhon, 1865, pp. 283–4.

35. See the article by Charles Léger on 'Proudhon et Courbet' in *Bulletin* No. 2, pp. 3 ff., and Rome 1969–70 (25). There are also two separate half-length portraits of Proudhon and his wife in the Louvre, both posthumous.

36. Bruyas, 1876, p. 350, in his entry for Delacroix's portrait of Bruyas, has the same impression: 'Delacroix sees M. Bruyas more in spirit than in reality . . . the very opposite of Courbet's materialism.' The reference to Delacroix's portrait is in his Journal for 16 April 1853 – the day after he had seen the Courbets at the Salon. Bowness, 1972 thinks it possible that Delacroix aroused Bruyas's interest in *The Bathers*. This seems to me very likely.

37. For the dating of Courbet's letters to Bruyas, see the detailed analysis in Appendix I. On *The Meeting*, see the fascinating discovery by Nochlin, 1967, pp. 209 ff. of the source for the composition in a print of the Wandering Jew. The two Courbet self-portraits, with the striped collar and the pipe, were stolen from the Musée Fabre in the autumn of 1970, along with the *Bridge at Ambrussum* and a study of one of *The Bathers*, but have now been recovered.

38. On Bruyas's dependence for money on his father, see Troubat, 1900, p. 106.

39. Winner, 1962, p. 173 presumes that Courbet's words to Champfleury: '*la société dans son haut, dans son bas, dans son milieu*' mean the upper, lower and middle ranks of society. This strikes me as a complete misunderstanding of Courbet's conception of the social hierarchies in this context.

40. This comparison invites the speculation as to whether Courbet also had abduction in mind when he painted this bather's posturing body. Is it conceivable that Jarves acquired his picture in Paris and not Italy in the 1850s? The resemblance does not look fortuitous. My inquiries from Yale relating to the Pollaiuolo have failed to clear up this point.

41. For further details about the Nadar Pantheon, see the catalogue of the Nadar exhibition, Bibliothèque Nationale, 1965 (Nos. 129 onwards). Kozloff, 1964, *passim*, has stressed the various levels of reality on which the artist operated when creating his picture, but, largely because the language in which he expresses himself is so hermetic, I find his arguments hard to follow. As I understand him, he is looking back at Courbet through the eyes of the Impressionists and Dubuffet, and interpreting the picture in the light of what happened to occur afterwards – an approach

to the subject the very opposite of my own. I therefore cannot do justice to his intelligent commentary.

42. The quotation from Champfleury is from *Le Réalisme*, Paris, 1857, p. 279; and from Proudhon: Proudhon, 1865, p. 285.

43. Adhémar, 1944, p. 10 and Bowness, 1972 have suggested that the picture could have been conceived in conjunction with Bruyas the previous summer, though there is no direct evidence. I am quite well aware that the Géricault was not yet in Bruyas's Collection, but this does not destroy my argument.

44. The interpretation of *The Studio* as a Fourierist allegory was made by Nochlin, 1968, p. 14. The description of Courbet himself as a Fourierist in the early days of his appearance in Paris is in an autobiographical note published in *Courbet raconté*, 1950, p. 27. His letter pronouncing himself as a socialist and republican of 19 November 1851 is quoted by Riat, 1906, p. 94. The remark about Courbetism is from Silvestre, 1856, p. 243.

45. Winner, 1962 investigates the pre-nineteenth-century representations of studio interiors and allegories of the arts. Frequently on Winner's own admission, Courbet owes nothing to them. To my mind this is a condemnation of the whole investigation. But to the German scholar it is sufficient to point out that Courbet was 'unconsciously indebted' (p. 172) to this tradition going back to the sixteenth century – a form of reasoning I find nothing short of bewildering. Bowness, 1972, was the first to relate the Glaize to the Courbet.

46. The first critic to propose the Rembrandt print as a source was, I believe, Hofmann, 1961, p. 19. The treatise in question is Alfred Dumesnil's *La Foi nouvelle cherchée dans l'art de Rembrandt à Beethoven*, 1850.

47. The Lugt Craesbeeck was engraved in the Arenberg catalogue (1829, no. 14) in reverse, so that the window appears in the engraving in the same relative position as in the Courbet.

48. For further details about the two exhibitions, see Appendix I, pp. 78-9. The entry from the *Delacroix Journal* is 3 August 1855.

49. Frequently transcribed; see Mack, pp. 108-12, and Borel, 1951, pp. 63-76.

50. Bruyas, 1854, p. 145. He quotes a very fragmentary passage from the letter. On another occasion (pp. 112-13) he quotes other passages from the letter without giving a date.

51. Bruyas, 1854, pp. 48-9.

52. Borel, 1951, pp. 25 ff.

53. Bruyas, 1854, pp. 116-17.

54. Borel, 1951, pp. 19 ff; Bruyas, 1854, pp. 185-7.

55. Bruyas, 1854, p. 187.

56. Borel, 1951, pp. 40-41.

57. Riat, 1906, p. 118.

58. *Bulletin* No. 5, pp. 22-3.

59. Borel, 1951, p. 39.

60. *Bulletin* Nos. 17-18, p. 28.

61. Borel, 1951, pp. 47 ff.

62. Léger, 1929, pp. 58-9.

63. Borel, 1951, pp. 58 ff.

64. *Bulletin* No. 12.

65. Quoted at length in text above, pp. 13-15.

66. Adhémar, 1944, p. 10.

67. *Bulletin* No. 12.

68. Borel, 1951, pp. 58 ff.

69. Mack, p. 132.

70. Borel, 1951, pp. 78 ff. A similar letter to Bruyas (Borel, 1951, pp. 85 ff) was obviously written soon afterwards, when he was making arrangements for the construction of the gallery.

71. *Bulletin* No. 15.

72. Borel, 1951, pp. 55 ff.

73. The order of the relevant letters to Bruyas as republished by Borel must therefore be amended as follows. Numbers are Borel's order, followed by his page references. Square brackets enclose the new dates. A few further facts are here given. 1, p. 17 [18 June 1853; so dated by Bruyas, 1854, pp. 47-8]. 7, p. 63 [about October 1853]. 3, p. 25 [January 1854]. 2, p. 19 [3 May 1854]. 4, p. 47 [late November or early December 1854]. 6, p. 58 [soon after 3 March 1855]. 8, p. 78 [soon after 15 May 1855]. 9, p. 85 [second part of May 1855]. 10, p. 95 [late autumn 1855]. 5, p. 55 [autumn 1857].

List of Illustrations

Colour plate and title page: *The Studio of the Painter*. By Gustave Courbet, 1854-5. Oil on canvas, 359 x 598 cm. Paris, Louvre. (Photos: Giraudon.)

1. *A Burial at Ornans*. By Courbet, 1849. Paris, Louvre. (Photo: Agraci.)

2. Key to the personages on the left of *The Studio*.

3. Key to the personages on the right of *The Studio*.

4. *The Peasants of Flagey returning from the Fair (Return from the Fair)*. By Courbet, 1850. Besançon, Musée des Beaux-Arts. (Photo: Studio Meusy.)

5. *The Bathers*. By Courbet, 1853. Montpellier, Musée Fabre. (Photo: Giraudon.)

6. Caricature of *The Studio*. By Quillenbois. From *L'Illustration*, 21 July 1855.

7. Detail of *The Studio*: the huntsman. (Photo: Museum.)

8. Detail of *The Studio*. (Photo: Giraudon.)

9. Courbet's studio at 32 rue Hautefeuille, Paris. From an etching by A.-P. Martial in Comte H. d'Ideville: *Gustave Courbet*, Paris, 1878.

10. Detail of *The Studio*: skull on newspaper. (Photo: Giraudon.)

11. *Self-Portrait*. By Courbet, 1852. Drawing. London, British Museum. (Photo: Museum.)

12. Photograph of Courbet. By Lalane and Defonds, *c*.1852. Paris, Bibliothèque Nationale. (Photo: Bibliothèque Nationale.)

13. Photograph of Courbet. By Nadar, *c*.1855. Paris, Bibliothèque Nationale. (Photo: Bibliothèque Nationale.)

14. Detail of 43.

15. *Self-Portrait in the Striped Collar*. By Courbet, 1854. Montpellier, Musée Fabre. (Photo: Museum.)

16. *Self-Portrait*. By Courbet, 1855. Ink on tracing paper. (Formerly Collection Henri Matisse). (Photo: Galerie Claude Aubry.)

17. Detail of *The Studio*: Gustave Courbet. (Photo: Giraudon.)

18. Detail of *The Studio*. (Photo: Giraudon.)

19. Photograph of a girl. By Jules Vallou de Villeneuve, *c*.1854. Paris, Bibliothèque Nationale. (Photo: Bibliothèque Nationale.)

20. Detail of *The Studio*. (Photo: Giraudon.)

21. *Huntsman Maréchal*. By Courbet, *c*. 1853. Whereabouts unknown. (Photo: Courtesy M. Fernier.)

22. Detail of *The Studio*: Maréchal, the farm labourer and the reaper. (Photo: Museum.)

23. Detail of *The Studio*. (Photo: Museum.)

24. Detail of 1.

25. Detail of *The Studio*: the lovers. (Photo: Courtesy Phaidon Press.)

26. Detail of *The Studio*: the art collectors. (Photo: Giraudon.)

27. *François Sabatier*. By Courbet, *c*.1854. Drawing. Montpellier, Musée Fabre. (Photo: Museum.)

28. Detail of *The Studio*: Alphonse Promayet. (Photo: Giraudon.)

29. *Alphonse Promayet*. By Courbet, 1851. New York, Metropolitan Museum of Art. (Photo: Museum.)

30. *Urbain Cuenot*. By Courbet. Philadelphia, Pennsylvania Academy of the Fine Arts. (Photo: Phillips Studio.)

31. Detail of 1. (Photo: Museum.)

32. Detail of *The Studio*: Cuenot and Buchon. (Photo: Giraudon.)

33. *Max Buchon*. By Courbet, begun before summer 1854. Here shown in reverse. Algiers, Musée des Beaux-Arts. (Photo: PAIR, Algiers.)

34. Detail of *The Studio*: Baudelaire. (Photo: Giraudon.)

35. *Charles Baudelaire*. By Courbet, *c*.1847. Montpellier, Musée Fabre. (Photo: Musées Nationaux.)

36. *Champfleury*. By Courbet, *c*.1853. Paris, Louvre. (Photo: Museum.)

37. Detail of *The Studio*: Champfleury. (Photo: Museum.)

38. Detail of *Proudhon and his Family*. By Courbet, 1865. Paris, Petit Palais. (Photo: Museum.)

39. Detail of *The Studio*: Proudhon. (Photo: Giraudon.)

40. *Pierre-Joseph Proudhon*. By Charles Bazin, *c*.1848. Paris, Bibliothèque Nationale. (Photo: Bibliothèque Nationale.)

41. *Alfred Bruyas*. By Eugène Delacroix, 1853. Montpellier, Musée Fabre. (Photo: Bulloz.)

42. *Alfred Bruyas*. By Courbet, 1853. Montpellier, Musée Fabre. (Photo: Museum.)

43. *The Meeting*. By Courbet, 1854. Montpellier, Musée Fabre. (Photo: Museum.)

44. Detail of *The Studio*: Bruyas. (Photo: Giraudon.)

45. *Alfred Bruyas*. By Courbet, 1854. Montpellier, Musée Fabre. (Photo: Museum.)

46. *Alfred Bruyas*. By Courbet, 1854. Montpellier, Musée Fabre. (Photo: Museum.)

47. *After Dinner at Ornans*. By Courbet, 1849. Lille, Palais des Beaux-Arts. (Photo: Giraudon.)

48. *The Stonebreakers*. By Courbet, 1849. Formerly Dresden, destroyed 1945. (Photo: Archives Photographiques.)

49. *The Sleeping Spinner*. By Courbet, 1853. Montpellier, Musée Fabre. (Photo: Giraudon.)

50. *Le Rêve de Bonheur*. By Dominique Papety, 1843. Musée de Compiègne. (Photo: Archives Photographiques.)

51. *Interior of a Room in Bruyas's House*. By Auguste Glaize, 1848. Montpellier, Musée Fabre. (Photo: Courtauld Institute.)

52. *Christ Preaching the Remission of Sins*, known as 'La Petite Tombe' (H. 256). By Rembrandt, *c*.1652. London, Victoria and Albert Museum. (Photo: Museum.)

53. *The Artist's Studio*. By Joos van Craesbeeck. Paris, Institut Néerlandais, Fondation Custodia, Collection F. Lugt. (Photo: Institut Néerlandais.)

Index

Superior numbers refer to the Notes.
Matters relating to *The Studio* itself,
and to Courbet in general, are not indexed.

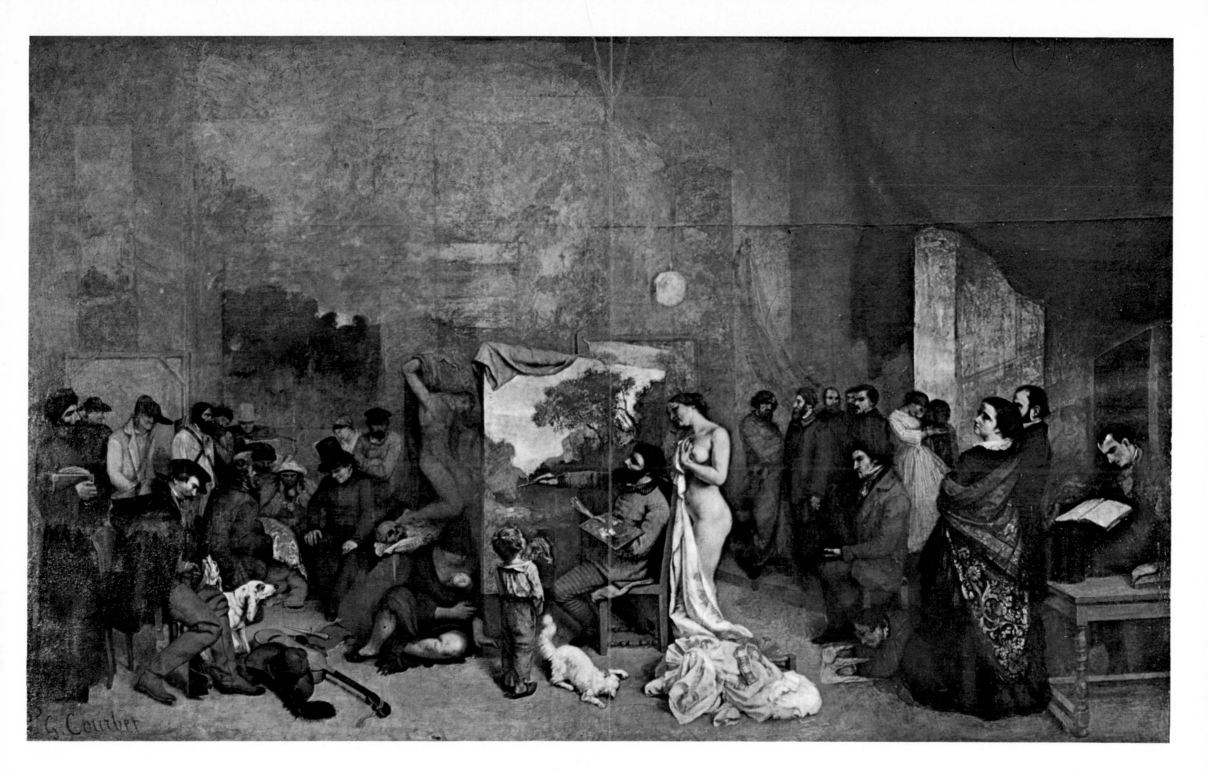